POSTCARDS FROM HOME

THE EDITORS OF *VOGUE*

POSTCARDS FROM HOME

CREATIVITY IN A TIME OF CRISIS

Rizzoli
NEW YORK

New York · Paris · London · Milan

Vogue commissioned and collected the images, interviews, and essays in this book in the spring of 2020 as the COVID-19 pandemic was taking hold around the world. Together they attempt to mark a moment of profound change and show how creativity and self-expression can thrive through crisis.

FOREWORD

By Anna Wintour

I DON'T REMEMBER THE DAY everything changed. That's probably because it wasn't one day, but a cascading series of them—all in early March 2020. We were still in the *Vogue* offices, meeting about the next issue, planning a traditional cover shoot, and then we weren't. We were glued to the news: the grim numbers from Italy, from France, the positive test from Tom Hanks, the NBA canceling its season, the World Health Organization declaring COVID-19 a pandemic. By the time New York City shut down, we were confined to our homes. But there was still an issue to deliver and deadlines fast approaching.

How do you produce an issue of *Vogue* during a global health crisis? Technically, it's not that difficult: Zoom and Slack and cloud-based drives make the process fairly easy for a group of editors working remotely. (Could we have pulled together an issue if a pandemic had struck in 1988, the year I arrived at *Vogue*? No chance.)

But how do you achieve this *creatively*? We couldn't send photographers or writers anywhere, or ship clothes, or book hair and makeup artists for photo shoots. We couldn't do *anything* via the normal methods. But we knew a normal issue of *Vogue* wouldn't do anyway— not at a time of worldwide anxiety and crisis. So we dropped everything we'd planned. We wiped the slate clean and started over.

What we created over the next several weeks would look like no issue of *Vogue* we'd ever made before. Our goal was to capture the world we were living in—and our starting point was to request self-rendered images from a collection of collaborators. We asked them to show us what their lives looked like under lockdown. These were people from *Vogue*'s world—fashion designers, artists and photographers, and actors and models we love—and their response was immediate and overwhelming. As scores of images began coming in, we called each to talk about what they had sent us.

The result was an explosion of personality and self-expression from a remarkable collection of talents— and an indelible sense that for all the losses that this pandemic has wrought, creativity is not one of them. "Creativity in a time of crisis," in fact, became both a theme of the project and a line on our cover—which appeared along with an allusion to the charitable fashion fund we set up with the Council of Fashion Designers of America, A Common Thread. "Our Common Thread," we declared, expressing the hope (which I still feel) that this crisis, for all of its isolation and distancing, may also bring us closer together. And the cover image we chose is one that gives me true joy: an unpublished (and breathtaking) photograph—*Rose 'Colour Wonder*,' 1970—by that master of image-making, Irving Penn. It would be *Vogue*'s first still-life cover in more than 50 years.

The above account of magazine-making may seem quaint in our digital age, but I should say that our approach was multiplatform from the start. In parallel to our physical issue, we built an enormous digital portfolio of still images and video to go live on Vogue.com the moment our issue went to press in late April. *Postcards from Home*, as we titled our omnibus project, was a multiplatform, multimedia portfolio designed for the time we were living through. And it garnered an immediate and positive response from readers and the wider world, one that continued to grow as we added interviews, images, and first-person essays to our site that captured life during the coronavirus. In those weeks, *Postcards From Home* defined *Vogue*'s point of view: authentic but optimistic, locked down but forward-thinking, restless for new ideas, creativity, and change. I am immensely proud of it. *Vogue* at its best.

From the start we knew that we wanted to refine and rework *Postcards* into a book—and I'm thrilled at the result. In the pages that follow, you will find the images and interviews that ran in our issue and online, as well as a collection of *Vogue* essays from that period that capture the range and humor and poignancy of what we published last spring. I want to thank all the editors who made this project happen—and it was a true group effort, from our visual team, to editors in features and fashion, to the copy department and the fact-checkers and our colleagues in production who pulled off an ambitious feat under difficult conditions. *Postcards from Home* achieves what we hoped it would: It marks a moment. It offers some permanence in a tumultuous, ever-changing time.

I hope you enjoy it as much as I do.

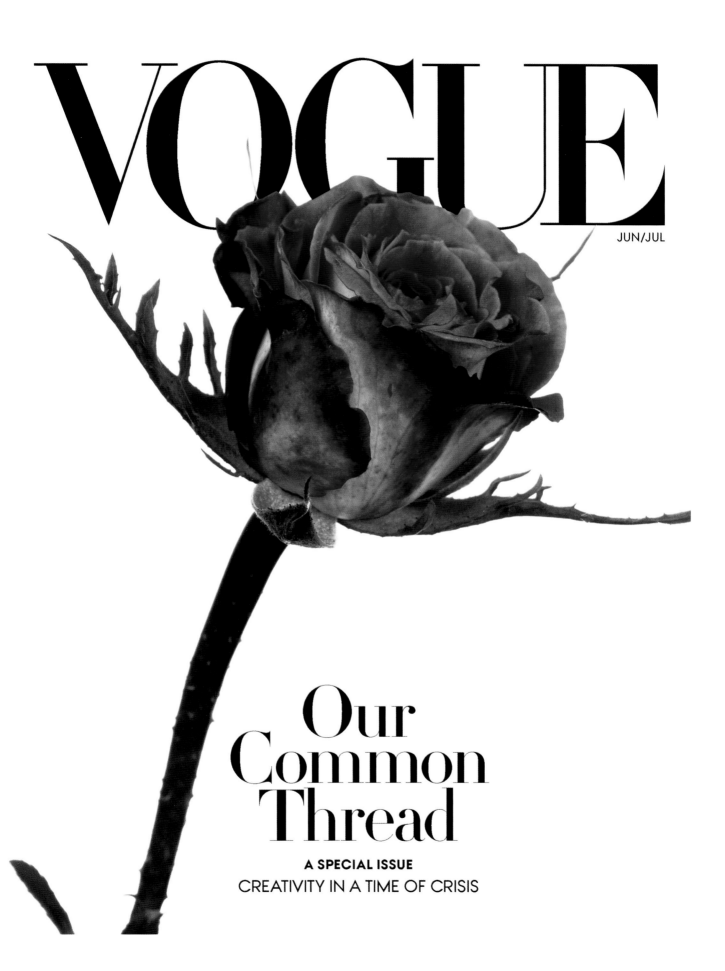

VOGUE

JUN/JUL

Our Common Thread

A SPECIAL ISSUE

CREATIVITY IN A TIME OF CRISIS

KAREN ELSON, NASHVILLE

"We're all just trying to adjust to the new normal," said the model and musician. "We have some good days; then we have other days where it's more challenging. To keep calm, I've been making music—picking up my guitar and learning a song I like. That's been really cathartic. It's an antidote for a lot of this."

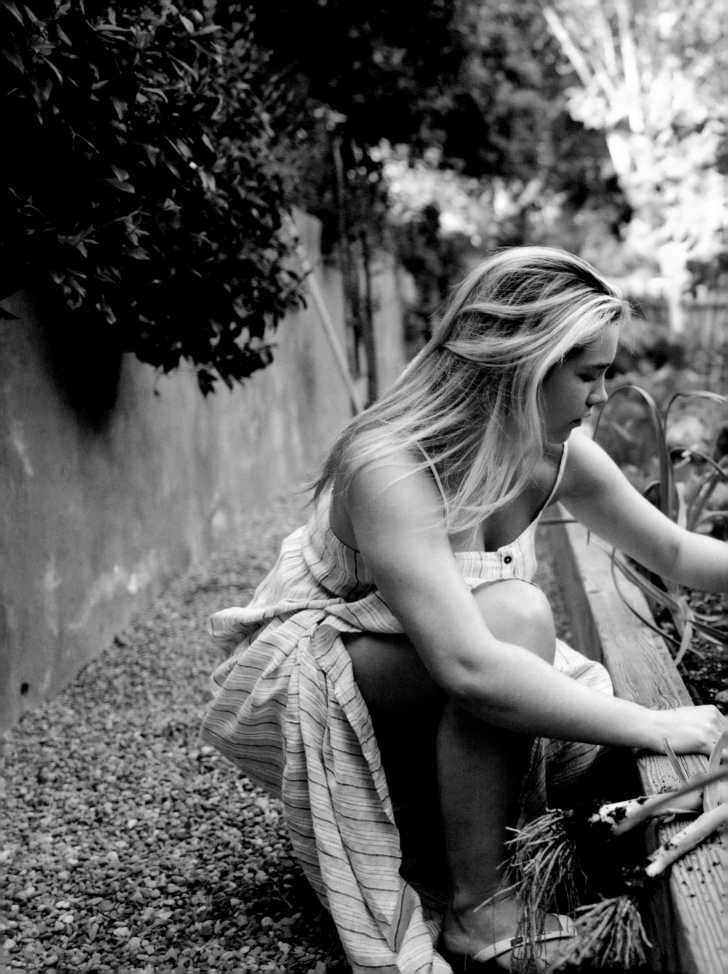

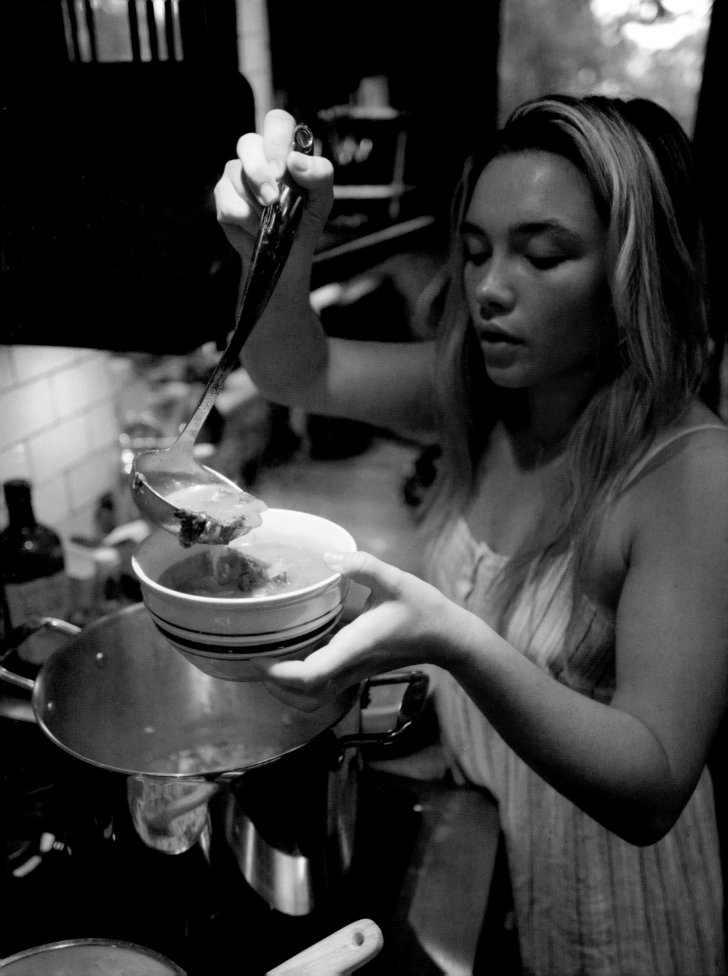

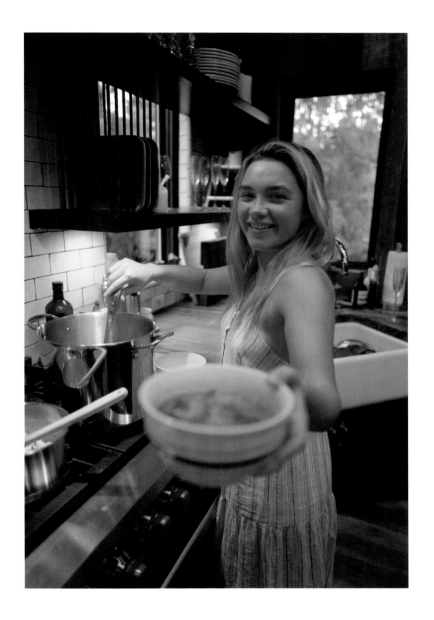

FLORENCE PUGH, LOS ANGELES

"For the first few days I felt low," the actor said. "Then my dad reminded me that I needed to dance and I needed to cook and I needed to do all of the things that make me happy. I instantly started shimmying and boogeying in the morning, and I felt so much happier and just...bubbly all day. I've also turned toward chopping and cooking and flavors. I have this vegetable patch (pictured on the previous pages) that I put in in autumn of last year, so that's where I'm getting all my cabbages and my leeks—and my elephant garlics! I'm totally finding a sense of calm in all the greenery. Meditation doesn't really work on me. I get very frustrated that my brain thinks about too many things. So I tend to turn to cooking and stirring. Last night I made a little kind of one-pot dish just to use all the things in the fridge, and it completely calmed me down."

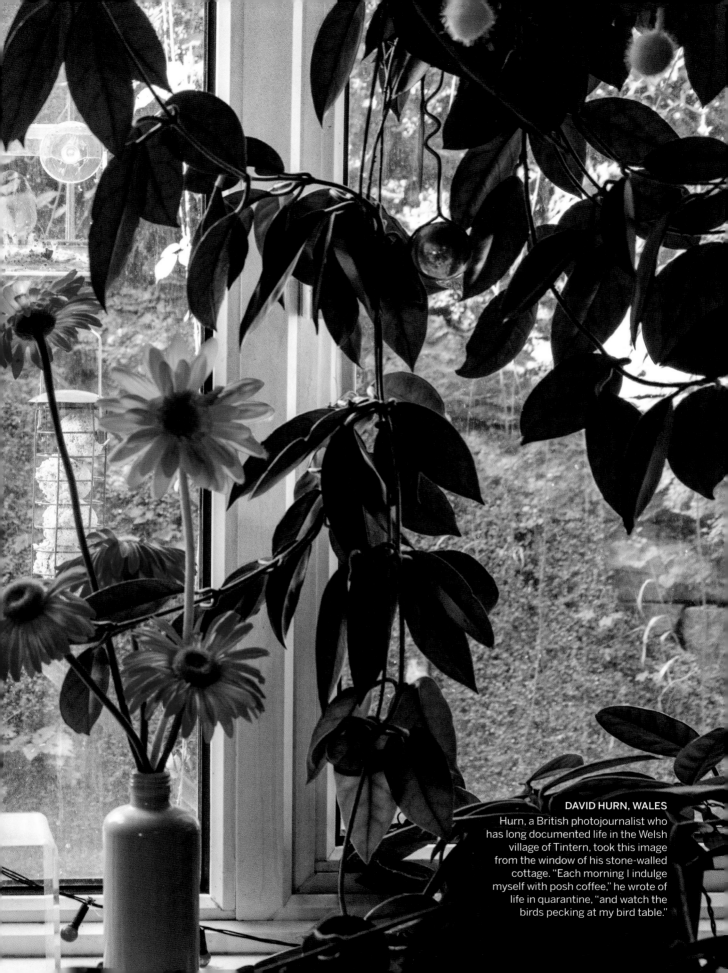

DAVID HURN, WALES
Hurn, a British photojournalist who has long documented life in the Welsh village of Tintern, took this image from the window of his stone-walled cottage. "Each morning I indulge myself with posh coffee," he wrote of life in quarantine, "and watch the birds pecking at my bird table."

IN THE WINGS

By Matthew Lopez

On the afternoon of Wednesday, March 11, 2020, I went to the Ethel Barrymore Theatre to catch the last few minutes of my play *The Inheritance*. It was a matinee day—part one in the afternoon, part two in the evening. We did three of these a week, a grueling schedule for the actors (the play runs six and a half hours in total), but they loved being able to tell the entire story in one go, for an audience that had committed to being at the theater all day.

The ending of part one, in which we honor those whose lives came abruptly to an end during the AIDS epidemic, has always elicited a strong emotional reaction. On this day, it was noticeably heightened. Someone upstairs was sobbing loudly, and their unreserved expression of grief seemed to give permission to the rest of the audience to feel their own.

After the curtain came down, I stood in the back, waiting for a friend who was at the show. I watched as people filed up the aisle in that now-unthinkable crush of proximity that once followed every live performance. Inside the theater, it felt like any other day at *The Inheritance*. Outside, there was the palpable sense that the bottom was about to fall out.

As we headed to dinner, my friend and I talked about the play and reminisced about the past—I met her in 1984 doing community theater together in my hometown. She was 26 and I was seven, and she quickly became an auntlike figure in my life. We spoke only obliquely about what was happening—her flight up from Florida had been nearly empty; her friends thought she was crazy for making the trip. We preferred instead to talk wistfully of the past and excitedly about the future. At that point, I did not know anyone who had contracted the virus. As I write this piece a month later, I know at least two dozen.

And I have lost a dear friend.

It's tempting to compare the epidemic we are currently living through to the one that's examined in *The Inheritance*—a contemporary reimagining of E. M. Forster's *Howards End* in which the AIDS crisis of the 1980s and early '90s is examined through the experiences of young gay men living a generation removed from the worst moments of that cataclysm. There are, of course, glaring similarities between then and now—a callous president dangerously out of his depth; a disastrously inept federal response. But unlike then, this virus has not singled out one particular community to ravage—all our bodies are vulnerable. Perhaps the most useful comparison isn't one of facts but rather one of feeling. Every conversation now seems to include the question, "Are you healthy?" We speak of our friends who have become sick. And daily, we watch the death toll rise. It seems as though the entire world is now experiencing a version of what it must have felt like to be a gay man in the 1980s.

As my friend and I walked back to the theater for part two, I had the sense that we might not continue our run to the final performance, scheduled for that coming weekend. That very day, a story had broken about an usher at a Broadway theater testing positive. The virus was rumored to be spreading through companies of certain shows. At my own play, access to backstage was now restricted to cast and crew only. Even I was not allowed past the stage door.

As I stepped inside the theater, I expected to encounter a half-empty house. But part two was completely full. From curtain up to curtain down, it was a brilliant performance—the actors all at the top of their games, their voices and bodies strong, their spirits high. Something told me not to duck out during the curtain call like I normally would, but instead to stay and watch, and to make a point of looking at each of the actors' faces as they bowed.

On my way home, I texted Tom Kirdahy, our lead producer: "I think I just saw the final performance of *The Inheritance*." He wrote back, "I hope you're wrong, but I'm glad you were there tonight."

The next morning, I received a text from the play's director, Stephen Daldry: "Rumor is they are about to shut down Broadway." Around noon, my husband, a private school administrator, texted to tell me they had decided to close the school. Then, a little after 2 p.m., the announcement came that all Broadway theaters would be shuttered for at least 30 days.

I called Andrew Burnap, Sam Levine, and Kyle Soller—the trio of leads who had been with the show for more than two years. "We talked about it in our dressing room last night," Andrew confessed. "We all felt we had just

MATTHEW LOPEZ is the author of the play *The Inheritance*.

given our final performance." We hung up, and they went to the Barrymore to clean out their dressing rooms.

My husband and I left the city that night for our house upstate, and I noted the irony of life imitating art: We were repeating the actions of two of my characters—leaving the city in the midst of an epidemic to quarantine in relative safety. We questioned whether we were engaging in an act of escape or one of self-protection. As a lifelong asthmatic, I was acutely aware of my perceived vulnerability to the virus, but given how contagious it seemed to be, would we be any more protected upstate than we would in the city?

Our answer came swiftly. A few days after we arrived, I began to develop what I suspected were symptoms of the virus: low-grade fever, headache, and difficulty breathing. The fever and headaches vanished within a day, the breathing trouble persisted for a week. Testing was at that point nearly impossible to obtain where we live, and so I hunkered down at home.

It was clear the virus had been spreading around New York for at least a month without detection. My earliest known exposure was March 2, when I had dinner with a group of friends, three of whom tested positive a week later. Three more people I directly encountered on March 11 and 12 also later tested positive. If what I had was COVID-19, any one of them could have given it to me. Or it's possible I caught it from a stranger on the subway. Or it's possible I didn't contract it at all.

The only thing we knew for certain was that since there was no avoiding this thing, we must instead avoid one another. And so began for me and my husband a new reality. We stayed at home, and we attempted to maintain a simulacrum of "normal" life. We read, we watched movies, we baked. (Well, my husband baked. I was the quality-control supervisor.) We FaceTimed with family and friends. Some days we obsessed over the news; other days we avoided it altogether. My husband worked around the clock to help prepare his students for remote schooling. I poured myself into a new film project. I was grateful for the escape, just as the audience at our last performance seemed grateful for the escape we were providing them.

I celebrated a birthday in quarantine, a heartbreaking one. Word had come that morning from Tom that his husband and my mentor, Terrence McNally, was on a ventilator at a hospital in Sarasota. I went for a walk with my husband in the woods by our house, and by the time we returned, Terrence had died.

A little over a year ago, the composer Marc Shaiman, with whom I'm writing a musical adaptation of *Some Like It Hot,* saw *The Inheritance* in London. When he returned to New York, he texted me a photo—it was of the list he had kept during the 1980s of those he knew who were sick and those who had died from AIDS. Taking Marc's cue, I

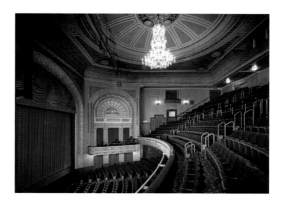
An empty Ethel Barrymore Theatre, where *The Inheritance* was staged.

opened a notebook and began to write the names of those I knew who had been sick from this new virus: Paul, Kevin, John, Bradley, Lukus, Ryan, etc. And then I wrote Terrence's name. In parentheses next to it, I wrote, "Died." I prayed in that moment it would be the only time I wrote that word in my notebook.

It is impossible to imagine life returning to "normal" after this—but life will return. If there's anything history teaches us, it's that all calamities end; and when they do, one of the first things people do in the aftermath is to tell stories about the experience. As my character Eric Glass explains, "Human culture from time immemorial has been transmitted through stories…and perhaps as a result of these conversations, passed along in some cases for millennia, history is conveyed and cultures survived."

I don't know when theaters will reopen. I don't know what it will look like when they do. No one does. In the absence of certainty, some theaters are already looking for creative solutions. Friends tell me they're already thinking about how to reconfigure their spaces to allow for social distancing within their auditoriums.

What is certain is that our hunger for stories has grown even more insatiable. Regional theaters streamed videos of canceled performances. The Instagram handle Theater Without Theater allowed creators to continue to share their work. National Theatre Live gave us the much-needed joy of watching *One Man, Two Guvnors* on YouTube. The original cast of *Hamilton* reunited one evening on Zoom.

People will gather once again to tell and be told stories. It is a fundamental part of human nature. We tell one another stories so that we will not feel alone in the world. We tell them to validate our own experiences, to hear the sounds of recognition in the audience. We tell one another stories because it is through telling stories that we are able to say, "I lived through this; this is what happened to me."

MIUCCIA PRADA, MILAN

"These days, when I am not working, this corner of my garden is a little consolation," the designer said.

FRANCESCO RISSO, MILAN

Marni's creative director shared the collage at right, which he described as a kind of Marni family portrait. "We've collected fragments of the notes, sketches, pictures, and conversations that kept us going over the past few weeks," Risso said. "On one hand is the pace of the industry, which did not allow us to stop completely. On the other hand is the challenge to do things differently."

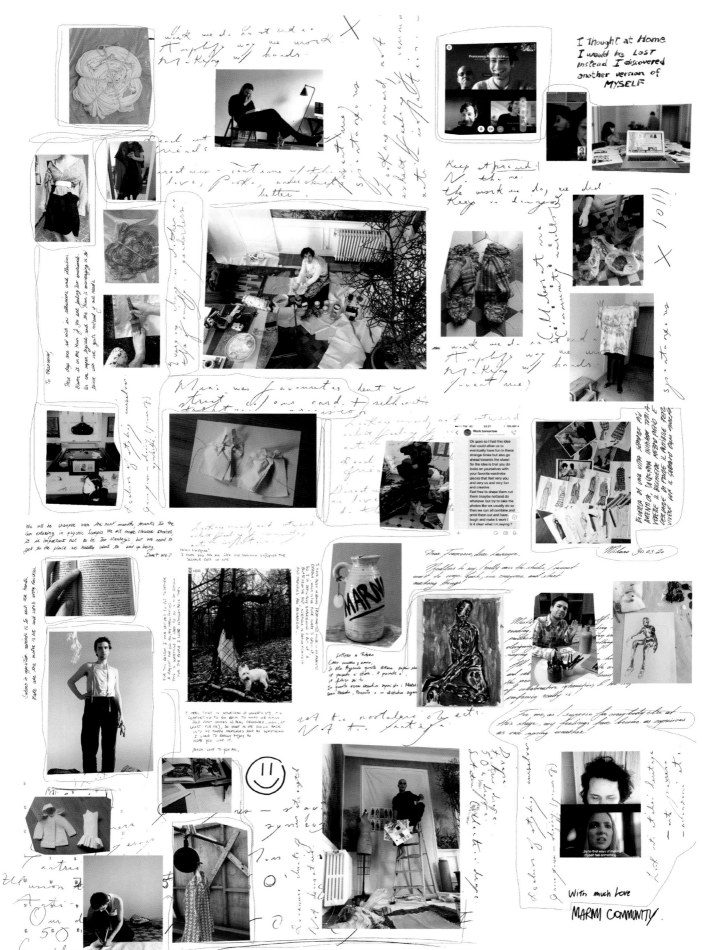

I thought at Home
I would be LOST
instead I discovered
another version of
MYSELF

With much Love
MARNI COMMUNITY.

NATACHA RAMSAY-LEVI, PARIS

"Being creative is to lose yourself in a book or a movie," said the Chloé creative director. "I don't have that time. For the moment I'm focusing more on intuition: What should the next collection look like? I'm going to an intuitive place."

PRABAL GURUNG, NEW YORK

"How do I create stuff that has been made responsibly and creates joy and happiness?" asked the designer. "We were moving toward sustainability slowly, but we should all be moving in that direction. We've been victims of a handbook that was written decades ago. It's out of date. More is not more."

DONATELLA VERSACE, MILAN

"People have rediscovered the importance of human contact because we have been forcibly deprived of it—maybe we will put a higher value on a hug or a smile or on the freedom that was so easily taken away from us," the designer said. "How does this translate to my work? I do not have all the answers yet, but I know they will come because I always look at the glass half full—and I never give up."

MARIA GRAZIA CHIURI, ROME

"I am working from home, and I like to alternate between working on new collections and working on personal things, like making family albums—and I often end up on the floor of my living room," said the Dior creative director. "I like looking at old pictures—the ones that turned out well and the ones that did not—letters, notes, postcards, drawings I made, and the ones my children made for me. It's something that brings me a lot of joy and serenity; it's like revisiting the tracks of one's life and the lives of those I love."

SIMON PORTE JACQUEMUS, MALLEMORT, FRANCE

Growing up, "I remember feeling alone in the countryside," the designer said, "trying to figure out what I wanted to say to the world. In a sense what I'm doing here now is what I've been trying to do my whole life, and that is to share positivity with others."

**GUIDO PALAU,
LONG ISLAND, NEW YORK**

"My boyfriend, Bill Tansey, is an
artist out here. This is one of his
paintings, and he just happened
to be standing in the light—there's
a silhouette of him on it," the
British-born hairstylist said. "When
everything's taken away from you,
like it has been for all of us, it's
amazing how little you need. With
warmth and food and health
and love, you can get through."

TOM FORD, LOS ANGELES

"Our son brings us optimism and joy," said the designer, pictured with his husband, Richard, their son, Jack, and their dog, India. "Our love as a family gives us strength."

JACK MCCOLLOUGH AND LAZARO HERNANDEZ, THE BERKSHIRES, MASSACHUSETTS

"We're thinking about: What is the future going to look like?" said Hernandez, who with McCollough designs Proenza Schouler. (They are joined above by their Newfoundland, Moose.) "Sustainability feels so much more important. It can't just be clothes—fashion has to mean something." Added McCollough: "Zooming with our team, calls with friends, listening to people share. We're hopeful. We feel a strong sense of community."

MARC JACOBS, NEW YORK

"I never thought a dress was a solution to a problem," said the designer, seen with his dogs, Lady and Neville. "But I do believe that as long as people are human, they'll want to dance and they'll want to get dressed and they'll want to eat good food and they'll want to engage in things that give them pleasure. I guess we just have to find a balance, or maybe rethink what all those things mean. But we all should be thinking about how we can change—or what we learned from this experience."

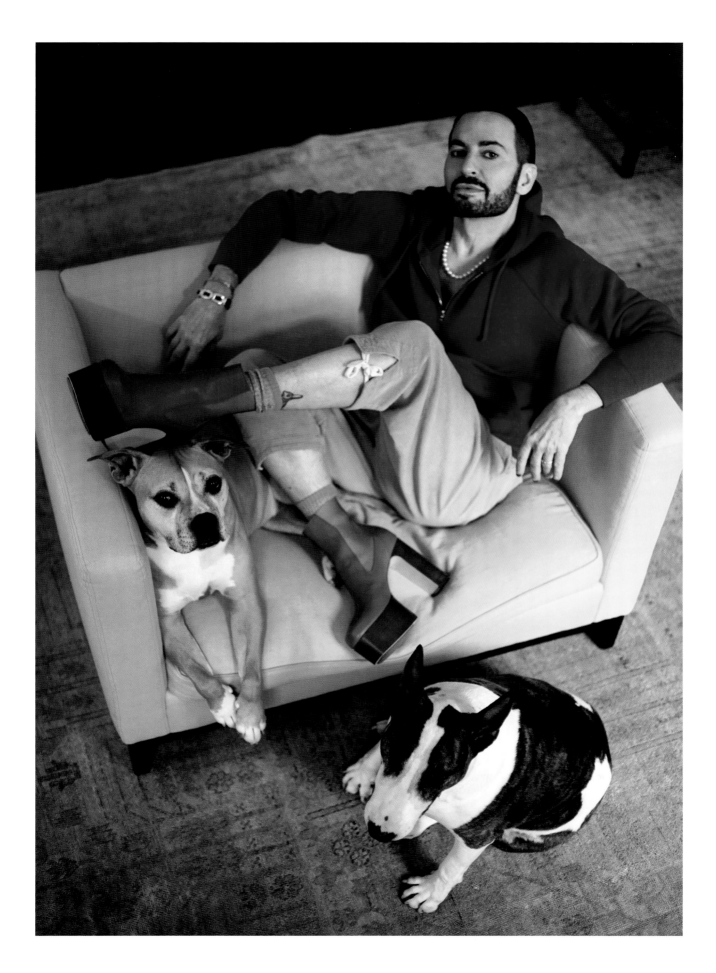

MAURIZIO CATTELAN,
GOOD NIGHT, 2020

For this project, the artist gave
Vogue something dark and
scary, but not without a touch
of humor—a portrait of himself
as a black-hooded executioner.
"This is a selfie, but you don't
even see the face," he said
from his home in Costa Rica.

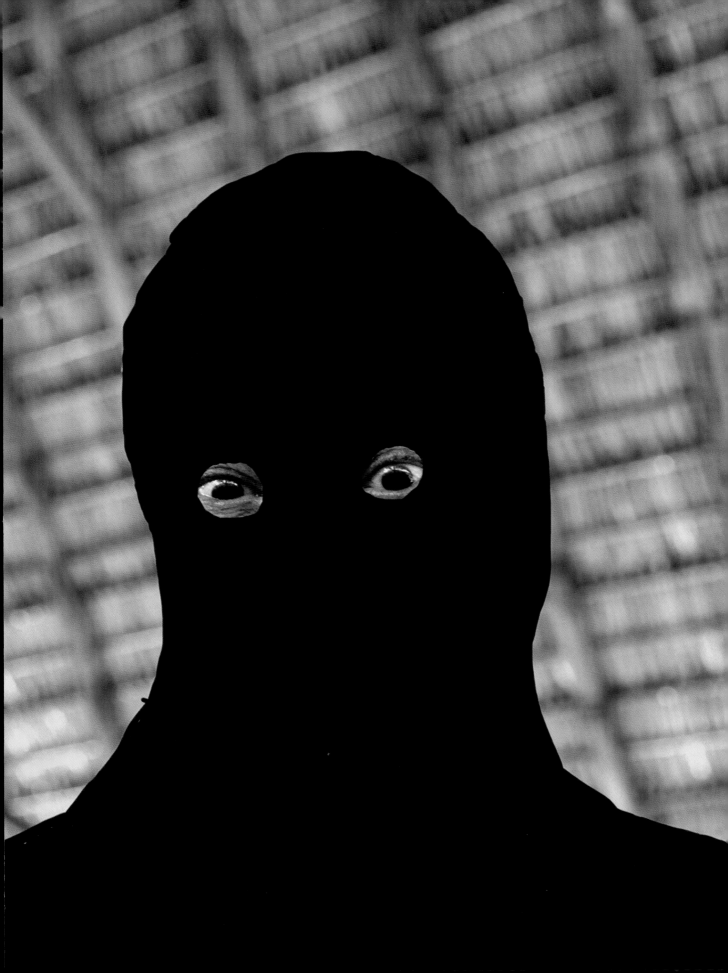

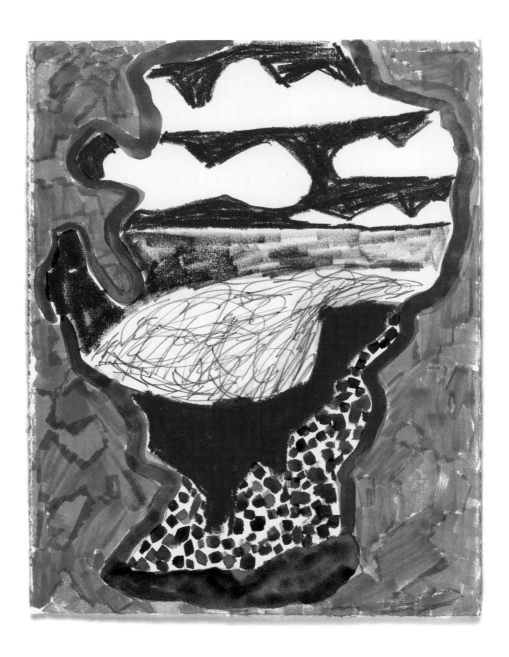

SHARA HUGHES, *SELFIE,* 2020

"Right now, this week, this hour, I'm nervous and emotional and unsure," said the Brooklyn-based artist. "There's what's happening inside the 'head shape' and what's happening outside. It all fits together, but everything is tight and fighting for its voice."

TSCHABALALA SELF, *SELF-PORTRAIT IN HOMEMADE MASK,* 2020

"It's been humbling to have everything in my life change so quickly because of circumstances outside of my control," said the artist, pictured in her New Haven, Connecticut, studio. "The virus has caused me to see myself as part of a whole, as opposed to an individual. It has shown me how interdependent we all are."

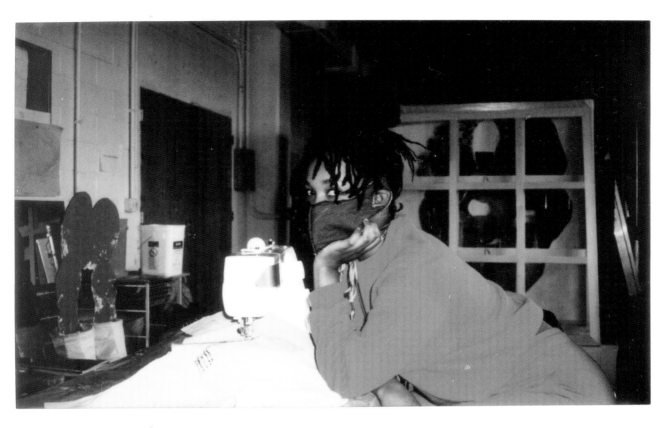

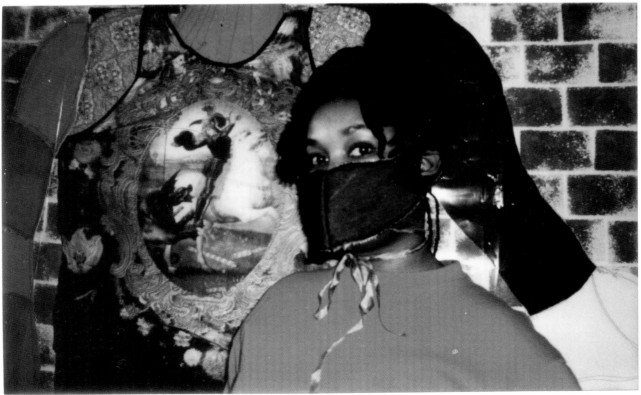

CINDY SHERMAN,
UNTITLED, 2020

From her home on Long
Island, the artist created a
close-up, double image of
her face, her nose pressed
against the camera lens.
"Have no idea what it
means," she said. "I suppose
it'll be *Untitled,* like
everything else of mine."

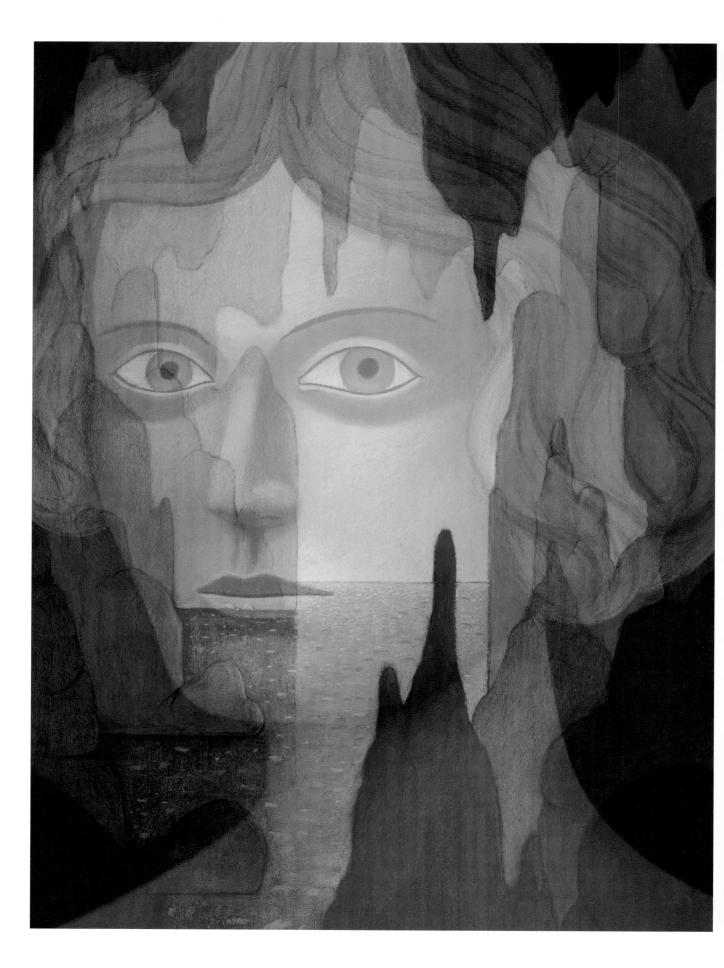

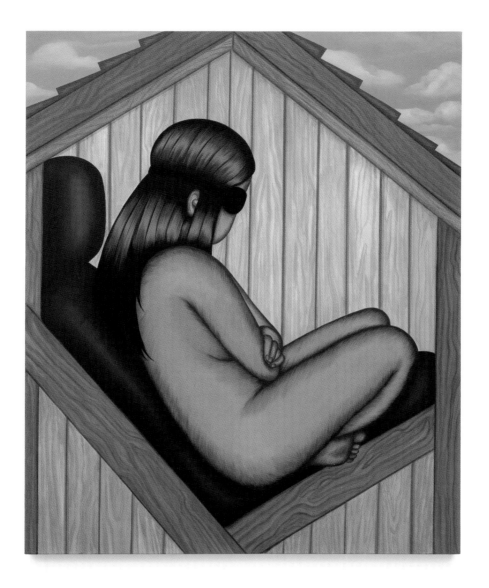

NICOLAS PARTY, *PORTRAIT AND CAVE,* 2020

The Swiss-born, New York–based artist had been thinking of Hayao Miyazaki's *Spirited Away* in quarantine. "When Chihiro enters a new world, she starts to become transparent," he said of the film's young heroine. In his new work, we look into and through the face of an androgynous figure and sense the underlying anxiety.

JULIE CURTISS, *SELF-PORTRAIT IN AUTARKY,* 2020

The Brooklyn-based artist completed this portrait—of a young woman, nude, wearing a blindfold and earplugs, crouching in a niche—shortly before New York's lockdown began. "Art can act as a mirror, as a window, and at times as a crystal ball," she said. Before, isolation "was about re-centering and connecting with yourself—but now you can't escape yourself."

THERMOM

SHOULD

FOREV

ED RUSCHA, *THERMOMETERS SHOULD LAST FOREVER,* **1976**

"It's mercury in a tube. Shouldn't it last throughout eternity?" asked the Los Angeles–based artist, who selected a lusciously pink pastel drawing from his archives to capture his current state of mind.

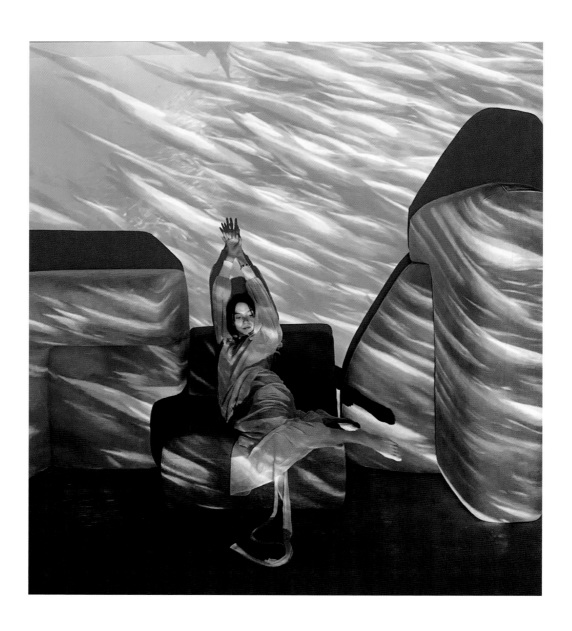

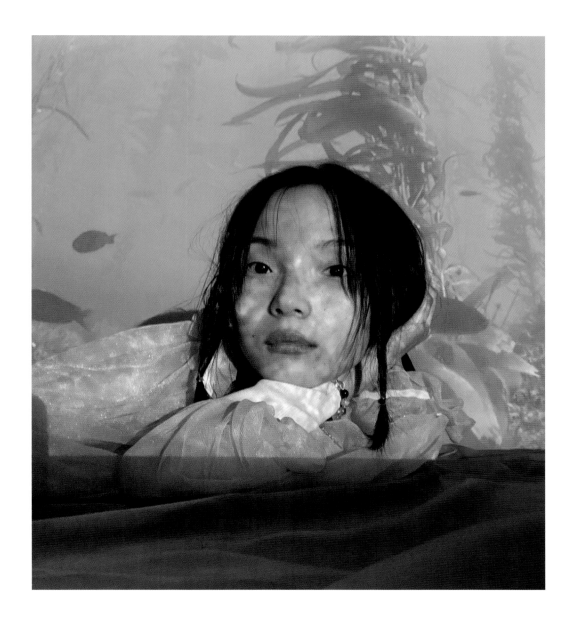

XIAO WEN JU, NEW YORK

"These photos were taken at my apartment in New York City," the Chinese-born model said. "I've been watching movies, reading books, and playing Animal Crossing. For me, less internet surfing means less stress. The most wonderful time of day is 7 p.m., when everyone is clapping for nurses and doctors through windows. I can feel the connection and energy in this city."

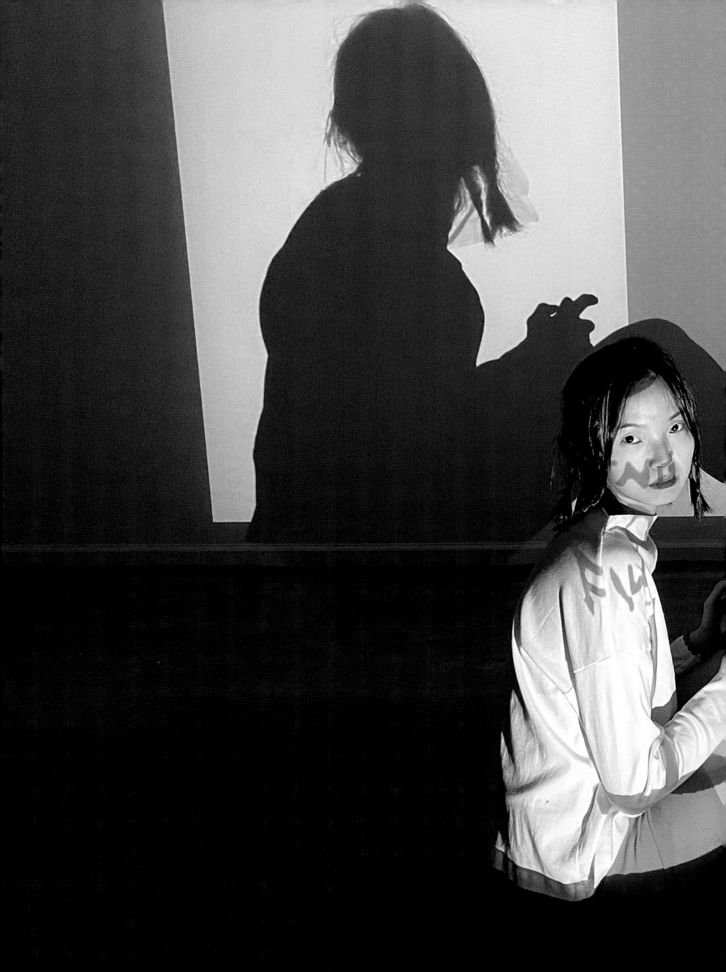

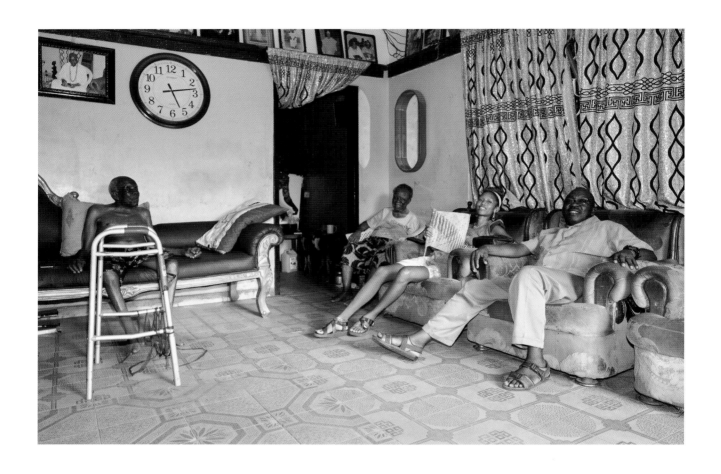

ADESUWA AIGHEWI, BENIN CITY, NIGERIA

"I'm at my grandfather's house," said the model. "When the world gets complicated, this is where I run to. And I'm seeing things on the ground firsthand—how many people don't have the resources to self-quarantine. I've been in the streets photographing from inside a car. I want to document what's happening, so the world can see who Nigerians are and how less-fortunate people especially are affected by world events like these."

PALOMA ELSESSER, NEW YORK

"Well, what have I been doing?" the model mused. "I've been reading, but have I been doing that consistently, every day? No. Have I been exercising every single day? No. The thing that's kept me grounded is randomly doing these Zoom calls and connecting on FaceTime with my friends and my family. That, and trying to have fun and get dressed every few days—you know, put some makeup on, put an earring on, or just dance around a little bit."

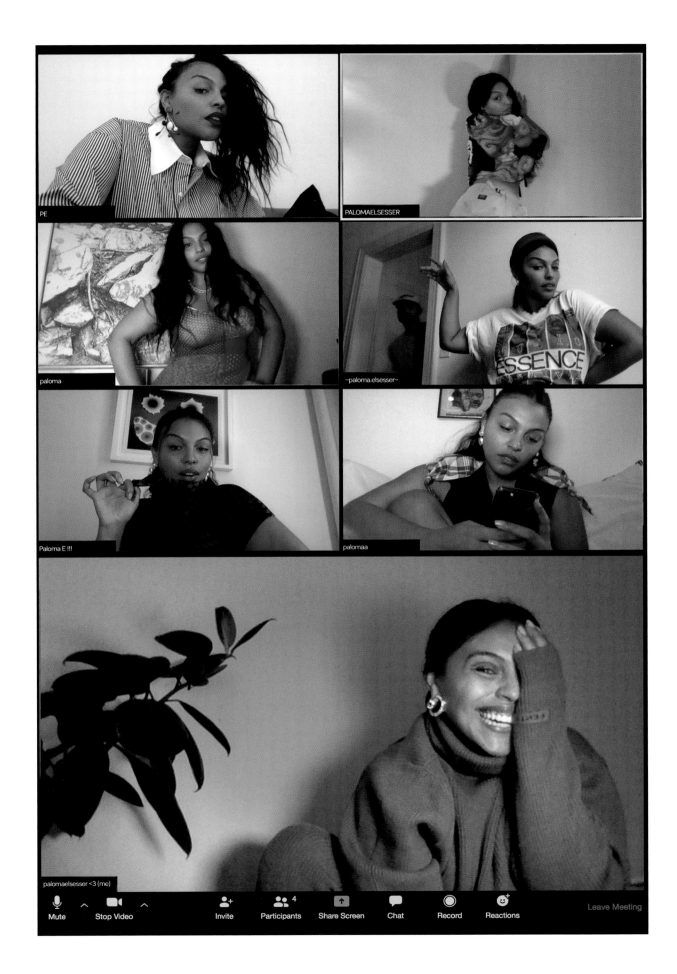

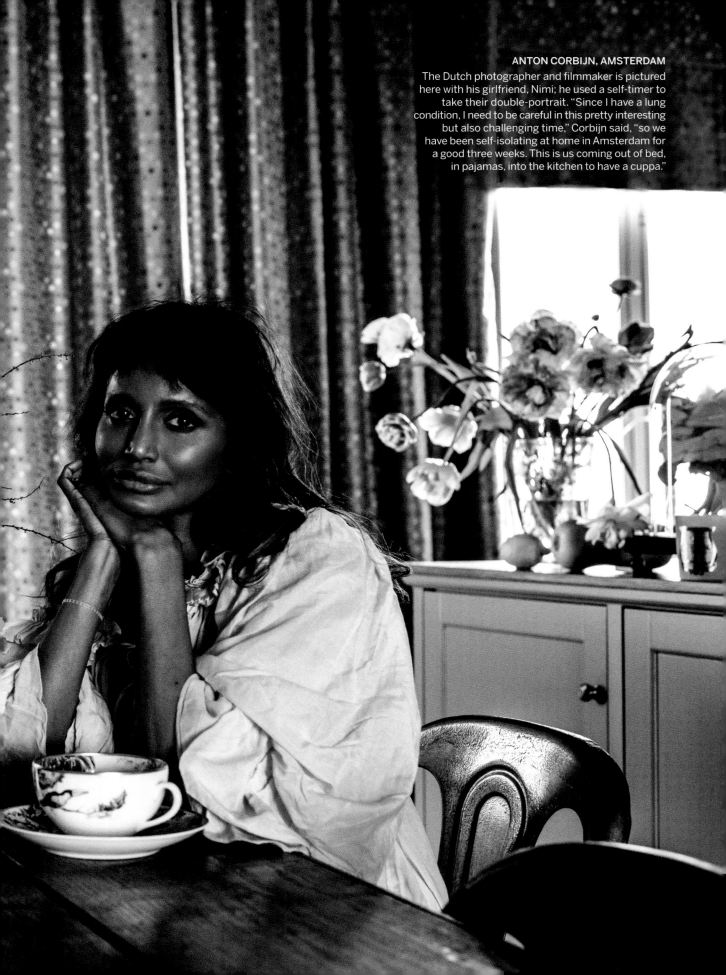

ANTON CORBIJN, AMSTERDAM
The Dutch photographer and filmmaker is pictured here with his girlfriend, Nimi; he used a self-timer to take their double-portrait. "Since I have a lung condition, I need to be careful in this pretty interesting but also challenging time," Corbijn said, "so we have been self-isolating at home in Amsterdam for a good three weeks. This is us coming out of bed, in pajamas, into the kitchen to have a cuppa."

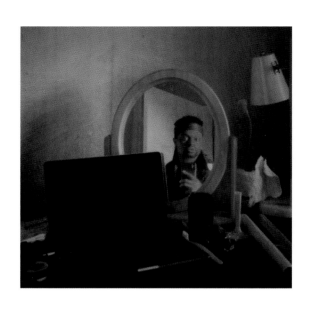

CAMPBELL ADDY, LONDON

"*In the Waiting* is an ongoing series where I attempt to take a photograph every day during my COVID-19 quarantine," the photographer and filmmaker said. Beyond documenting "these anxious times," he added, the project worked as a reminder "that stillness is also life, and chaos can birth beautiful ideas."

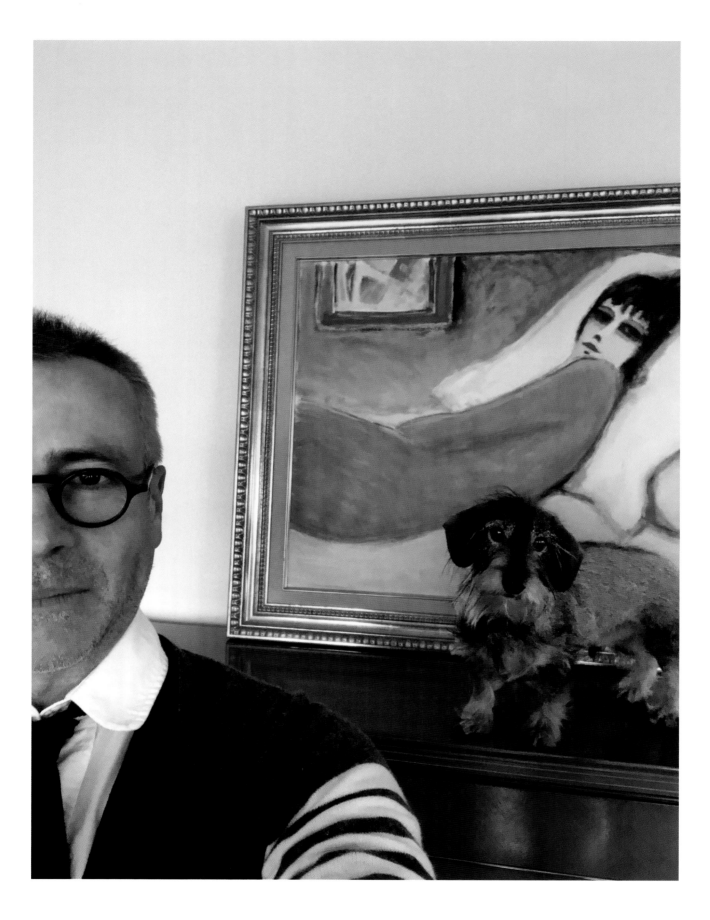

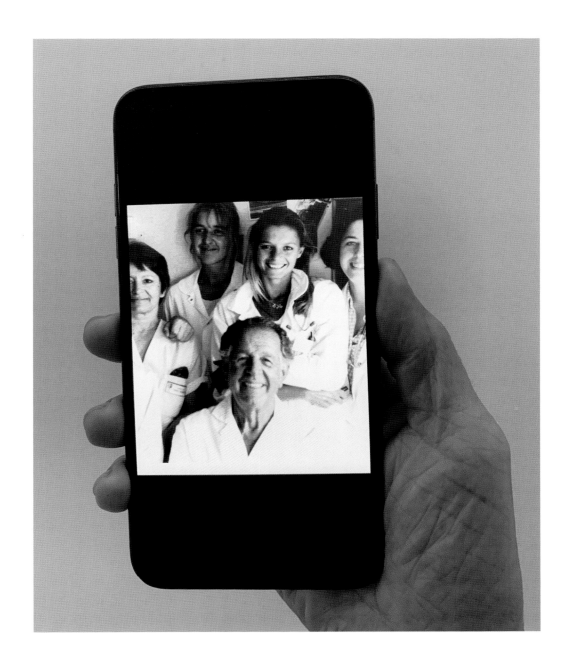

THOM BROWNE, NEW YORK

"I'm one of the lucky ones—I have Hector (Browne's dachshund, pictured) here, Andrew (Bolton, his partner) here—it's a nice place to be, the comfort of someplace familiar," said the designer. "What we're living through can really suck you down, but you have to figure out how to stay positive. It certainly makes you appreciate the truly selfless people who are getting us through these times—people working in hospitals and grocery stores."

VIRGINIE VIARD, DRÔME PROVENÇALE, FRANCE

"I love this image of my father surrounded by so many young and smiling faces," said the Chanel creative director. "Both my parents were doctors, and my father"—pictured here with colleagues from the hospital where he worked—"was always smiling despite the hard situations he might have been facing. Every Sunday afternoon as a child, I would dress up as a nurse or doctor and accompany him to the hospital to meet and cheer up some of his patients. Those were special moments. When I think of my parents—and when I see all the efforts made in the hospitals—I still have hope for the future."

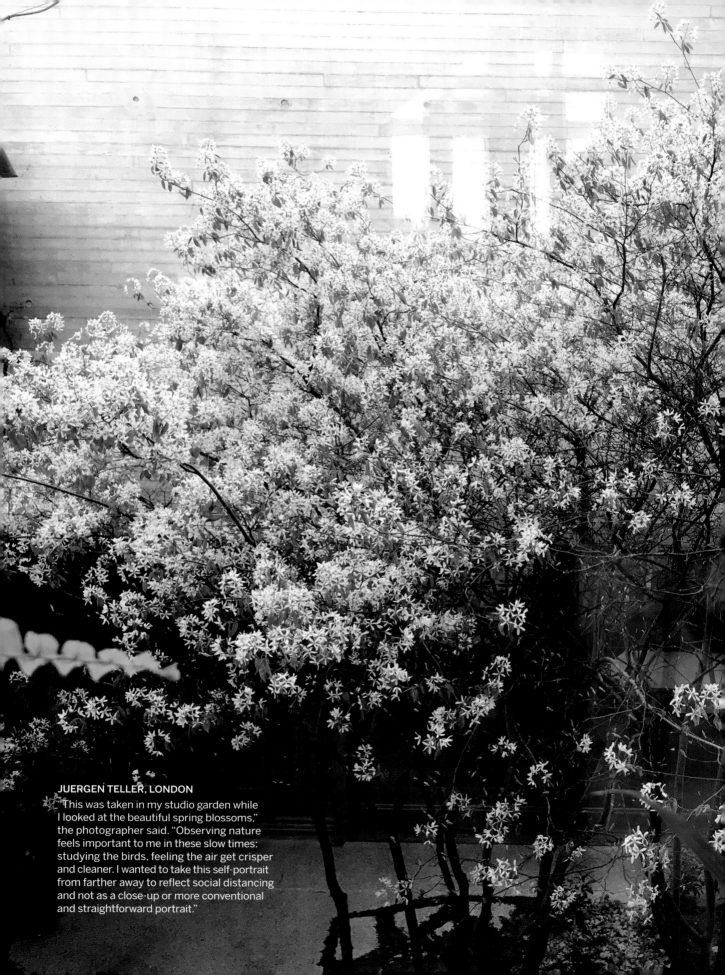

JUERGEN TELLER, LONDON
"This was taken in my studio garden while I looked at the beautiful spring blossoms," the photographer said. "Observing nature feels important to me in these slow times: studying the birds, feeling the air get crisper and cleaner. I wanted to take this self-portrait from farther away to reflect social distancing and not as a close-up or more conventional and straightforward portrait."

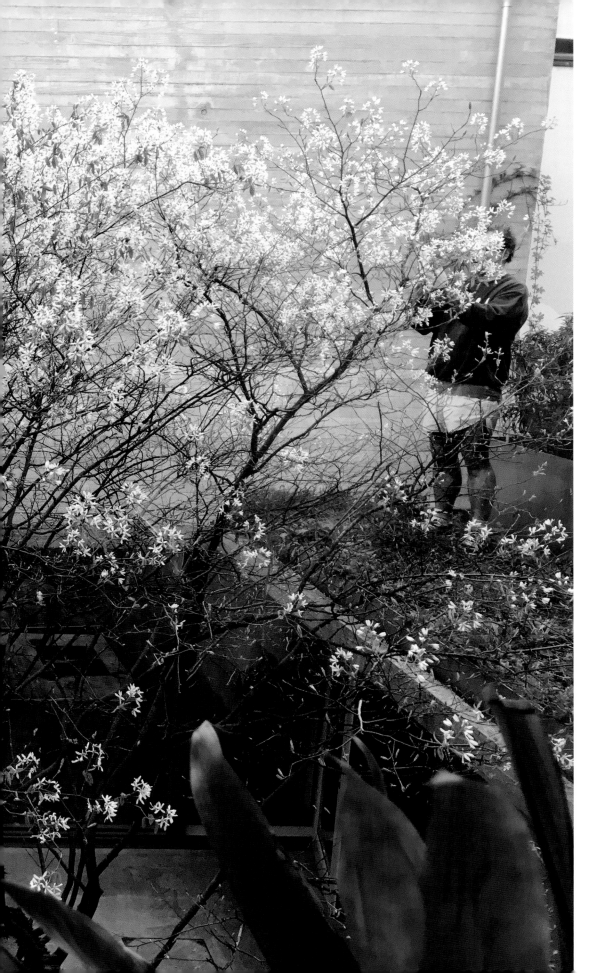

BIBI BORTHWICK, LONDON

"Isolation has given me so much time to
breathe. After nonstop travel the past few
years, this moment of stillness has been
really grounding," the photographer said.
By and large, her idle hours were devoted
to "reading a lot, meditation, connecting
with friends and family around the world,
and living in the present moment."

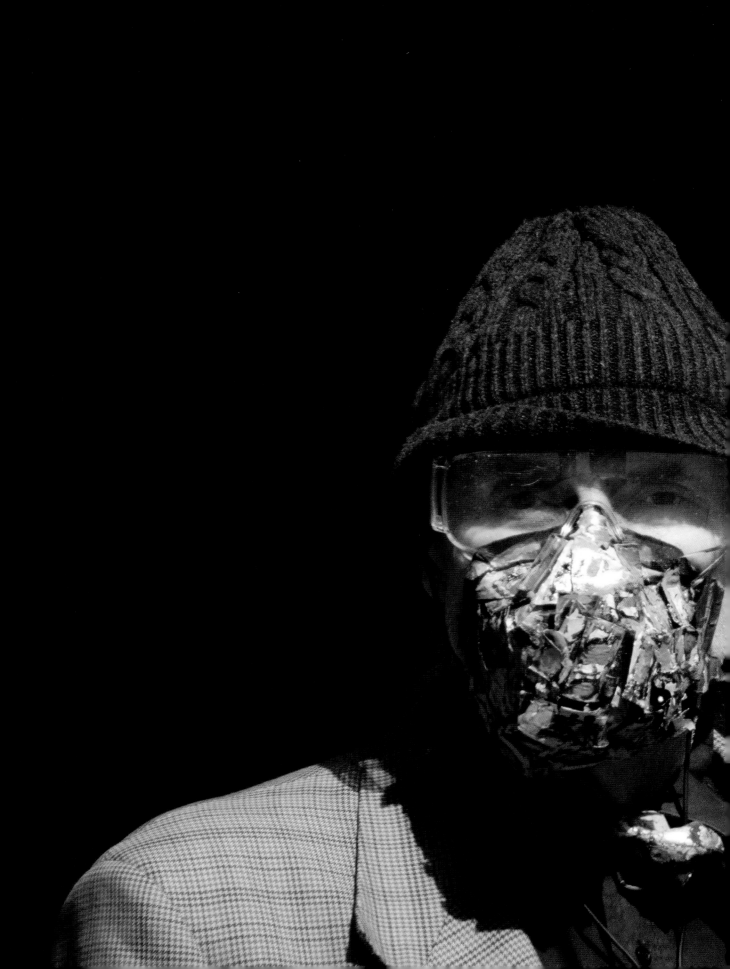

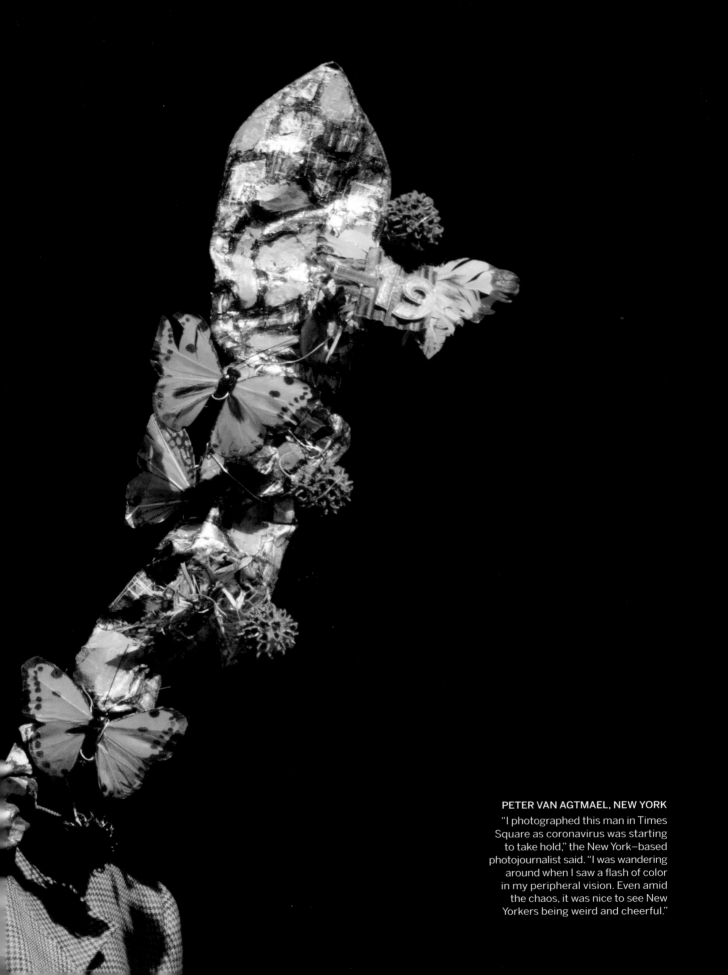

PETER VAN AGTMAEL, NEW YORK
"I photographed this man in Times Square as coronavirus was starting to take hold," the New York–based photojournalist said. "I was wandering around when I saw a flash of color in my peripheral vision. Even amid the chaos, it was nice to see New Yorkers being weird and cheerful."

TRACEE ELLIS ROSS, LOS ANGELES

"Fear comes in waves, grief comes in waves, both for our world and also for the disappointments of plans that I had, ideas that I had, and for the things that are different: being able to touch your family and your friends. Being able to be in physical contact with people," the actor said. "This Balenciaga suit is what I wore for my conversation with Oprah on her 2020 Vision Tour, right before all of this hit. It feels good to put on a power suit even though it's just to sit in my favorite spot on my couch. A reminder that all that brought me to that conversation is not gone, but life has just shifted direction. I remain the same woman even though life is very different now."

OLIVIER ROUSTEING, PARIS

"Fashion should be connected to what's real," said Balmain's creative director. "It should do something that reflects our world and has some meaning. It should be making us think about how to do something better. I expect a lot of great things to come from this moment. We were living in a bubble. Today we realize there is only one bubble that's important: our planet."

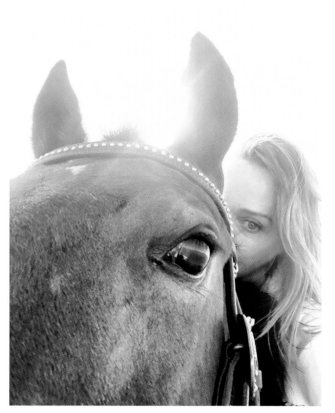
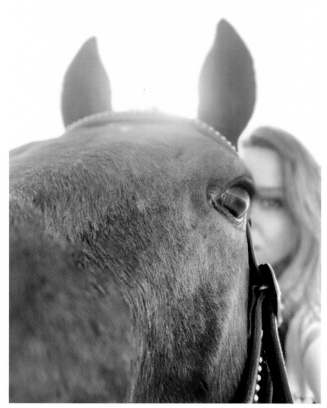

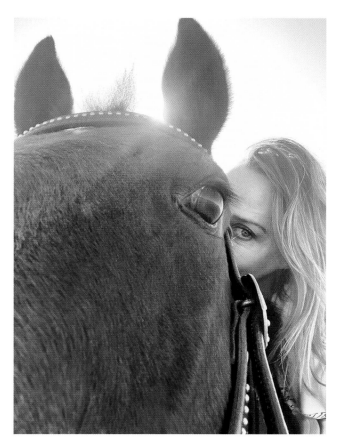
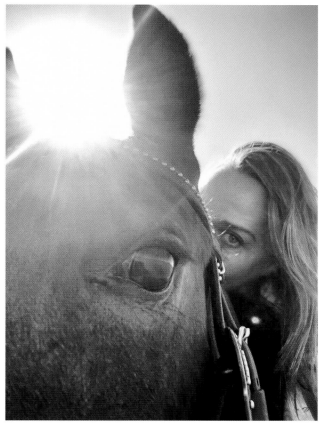

STELLA MCCARTNEY, GLOUCESTERSHIRE, ENGLAND

"That's my horse, Summer," the designer said. "I think there's a level of emotional support from animals right now. As a working parent, I've always wanted to just be living in the country with my kids and my horse and just being a mom and everything that involves. My brand's core value system is very much one of connectivity—to nature, to our fellow creatures. For me, the hope is that out of all of this suffering and nihilism comes some more mindfulness on how we got here. I've said to all my teams that it would be a real disservice if we didn't come out of this moment with a deeper level of thought as to what we do and why we make things and how we make them."

KIM KARDASHIAN WEST, LOS ANGELES

"We're in the theater room," said the celebrity and businesswoman. "That's the place that has gotten the most use lately. The whole family has spent the last few nights in there after the kids made it into a fort, with, like, different beds all over the floor. My daughter is the fort police. If you move out of your bed that she designated for you, it's a problem."

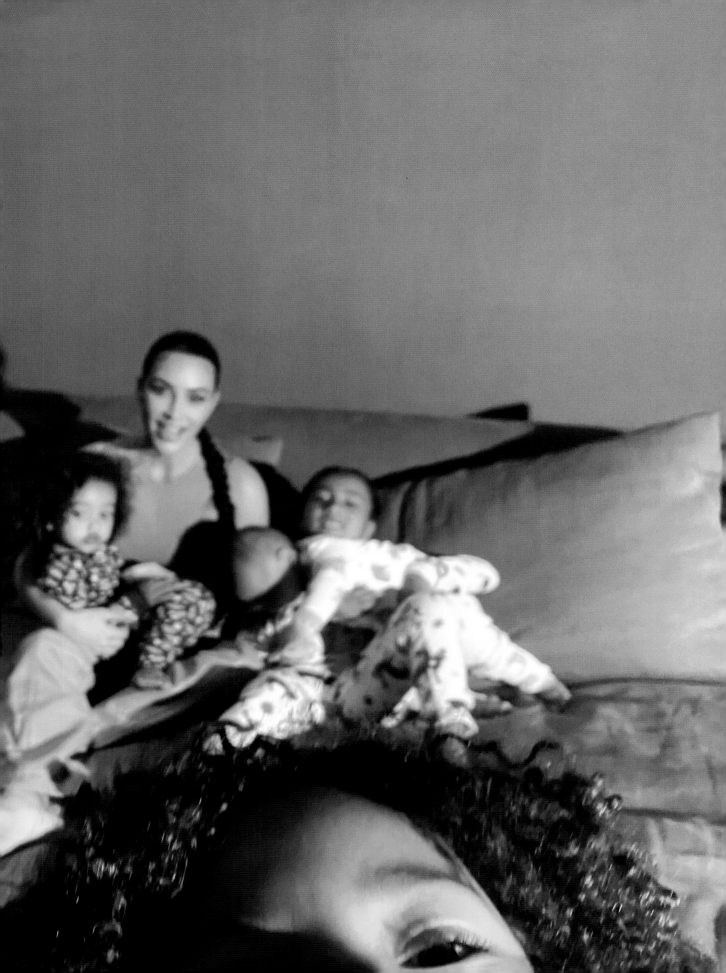

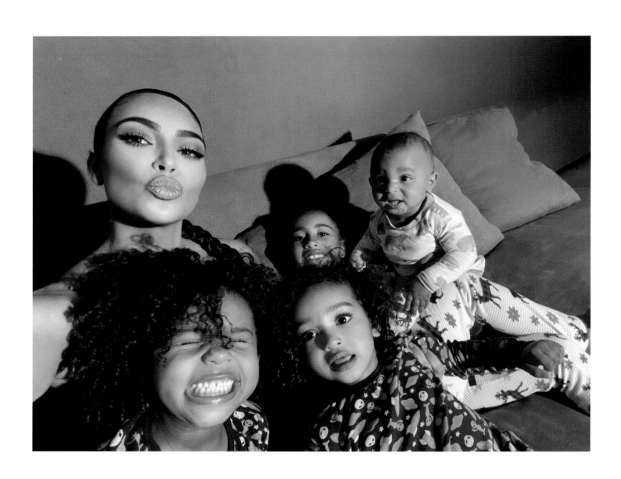

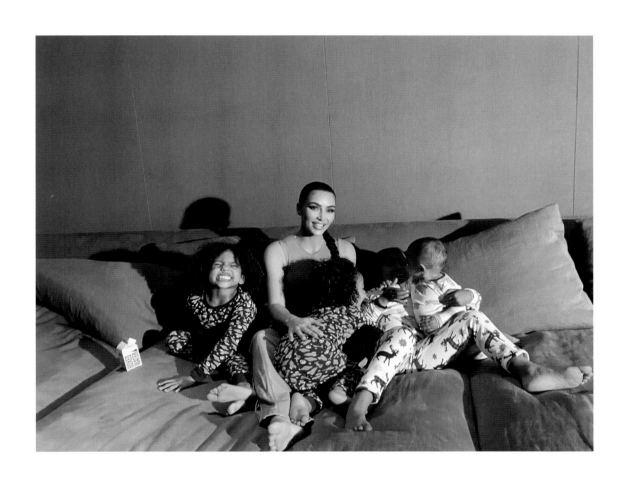

VIRGIL ABLOH, CHICAGO

"The ax—it's not a real ax; it's an art piece from Sterling Ruby," said the Off-White founder and Louis Vuitton men's artistic director. "I'm hanging up art and building a new workspace, a recording studio. *Under Construction* is kind of the title of the image. I'm inspired that fashion can mean something different out of the end of this. It doesn't feel like it did a year ago. Today it seems useless, in a way: a new handbag, a pair of shoes. Getting groceries seems more important than buying a new garment that I already have 30 of in a closet. I don't think of that as a bad thing. I'm also trying to find some solitude. You hear about these things: wellness, well-being. Meditating—that's something I need to learn. I'm relishing the idea of not having to do something all the time, but that's a trait I have to learn. I'm not wired that way."

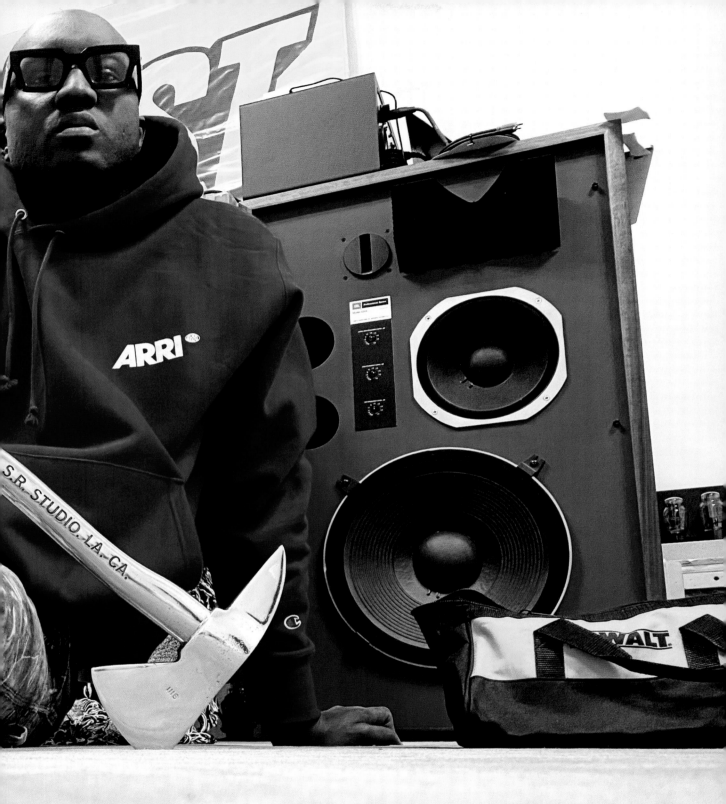

WHY I AM NOT LEAVING NEW YORK

By Molly Jong-Fast

For the most part, the concerned phone calls have stopped. "You're leaving, right? You're going to…" and then they name some theoretically safer suburb or vacation community that I am not going to go to. But the calls have stopped because it's too late to leave now. A few days ago, Dr. Deborah Birx, the response coordinator for the White House task force on the coronavirus, said that 60 percent of all the new cases in the United States are coming out of the New York City metro area, adding, "Everybody who was in New York should be self-quarantining for the next 14 days to ensure the virus doesn't spread to others no matter where they have gone."

If I wanted to leave, I should have left a month ago. But I have no intention of leaving.

I'm always enraged by the assumption that I would leave my city—the only place I've ever lived—in her hour of need. I am not leaving New York. Not that a smart person would stay. My apartment building is almost empty. And I can't blame them. New York City isn't normal. New York isn't even post-9/11 New York. No, pandemic New York is completely different than any New York I've ever experienced in my 41 years of New York.

I've never left New York. I'm not one of those people who went to seek their fortunes elsewhere. I grew up in New York; both of my parents grew up in New York. My children are growing up in New York. This is not a phase for us; it's a pathology. We are more New Yorkers than we are Americans. But the New York of right now is not the New York that we have known for all our respective lives. It's more like post-nuclear-disaster Chernobyl.

We're the epicenter of a pandemic. We're Milan. We're Wuhan. We're a cautionary tale. Every day around 11 or so, Governor Andrew Cuomo tells us what's happening in our broken city: "New York is your future. New York is a warning." The warning is that other cities could soon drown in a sea of bodies, just like we are. Our morgues are almost at capacity. Our hospitals have lines that snake around the block. Our doctors are on TV every night begging for 99-cent masks to shield their faces. "The apex is higher than we thought, and the apex is sooner than we thought," Cuomo tells us. "New York is the canary in the coal mine. New York is going first…. What happens to New York is going to wind up happening to California, to Washington State, and Illinois—it is just a matter of time."

What I'm mostly struck by is the newfound silence of New York. I live on a busy intersection that is no longer busy. The flow of traffic throughout the city has reduced to a trickle; the cars are almost gone, with maybe a stray taxi. Where I live there are only trucks—food trucks, garbage trucks, and then ambulances, loudly piercing the flesh of my eardrums as I try to sleep. I don't sleep anymore, not like I used to when the coronavirus was in Wuhan and I was just maybe a little worried that it would eventually come here. I don't sleep like that anymore. I sleep fitfully, the way fearful people sleep. I can't fall asleep, and when I sometimes do, I can't stay asleep. And the dreams I have are horrible: They're a mosaic of worry and fear. Occasionally there are dreams that are not terrifying—and those dreams are the worst of all because they make me worry that I'm dead or going to be. One night, I dreamed of building my beloved 89-year-old father-in-law an enormous house. Did it mean he would die or that I would die or that we *both* would die?

Sometimes life in New York City is disturbingly normal: Recently, the parks were filled with people playing sports and looking healthy. If you squint, everything seems almost normal. In Central Park, the city looks like it's not bleeding. I still go for my walks with my friend, the *Washington Post*'s media columnist Margaret Sullivan (six feet away from each other), and she tells me why she is also staying put. "Maybe it's the journalistic instinct," she says. "New York City is going through a historic moment, and I didn't want to remove myself from that. I simply want

MOLLY JONG-FAST is a writer in New York City.

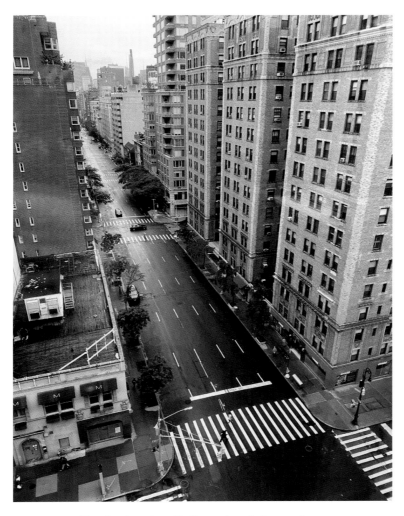

The view from Jong-Fast's apartment of a once-busy intersection, taken on May 17, 2020.

to see it and feel it. And so far, I'm not sorry to be here, though it is breaking my heart every day. It's heartbreaking to see the signs on the doors of all my favorite places— my hole-in-the-wall Lebanese restaurant, my favorite nail salon, the coffee joint with the perfect music. It's heartbreaking to know that the homeless people who are usually neighborhood fixtures have retreated inside shelters that probably aren't safe for them. And it's frightening and upsetting to read the stories of the hospitals so close to me where people are dying and medical personnel are overwhelmed."

Mostly life here is heavy with the dread of death, like a soupy thick gray fog that coats everything. First, the friend of a friend dies. Then a famous playwright I met a few times, then an art critic, then there's a pause and I don't want to look at the newspapers anymore. The *New York Times* now has a special coronavirus section of the obituaries, called Those We've Lost. I read it every day with rapt attention. Is the person older than I am? Do they have a preexisting condition? I'm reminded of a video from Italy, showing pages and pages of obituaries. It seems inevitable that we will be there in a matter of days.

Many of my friends have left, gone to parents' or friends' or summer houses. They were scared, and who can blame them? I'm scared too. Every time my asthmatic teenage son coughs, I wonder if I made the wrong choice to stay. Am I irresponsible? Am I selfish? Am I a terrible parent? I don't know, maybe. But I'm here in my city, my poor broken city, as she shakes and her people suffer. We're all scared, and we should be. But I'm here and I'm not leaving.

Sometimes at night when I lie in my bed haunted by the silence of the city streets, I am convinced that I am a violinist on the *Titanic,* playing away to keep myself from being afraid.

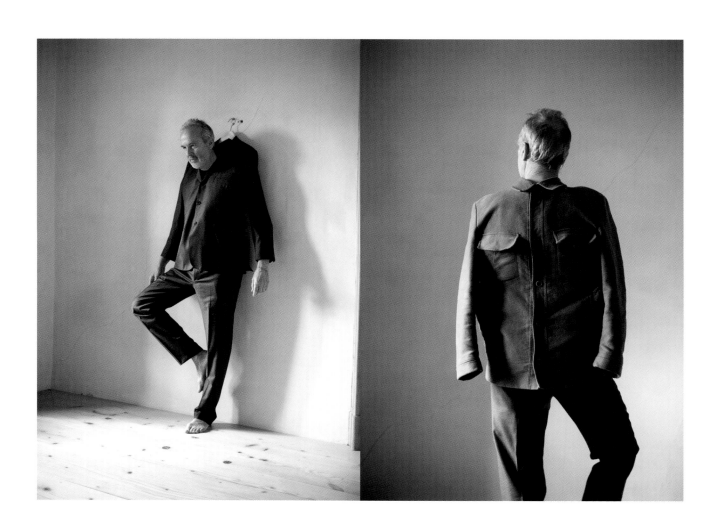

ERWIN WURM, LIMBERG, AUSTRIA
Best known for his playfully
performative series, *One Minute
Sculptures,* the artist reported that
he, his wife, Élise, their daughter,
Estée, and Tini, the family dog
(pictured with Wurm and Estée
on the following pages) were
all "home safe, hiding, protecting
each other, and playing around."

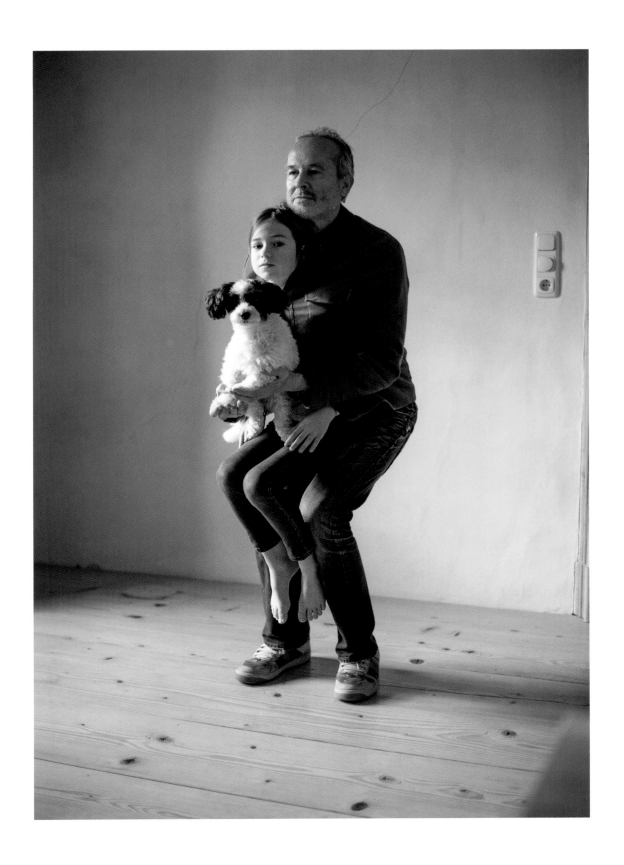

SIENNA MILLER, WESTCHESTER COUNTY, NEW YORK

"Having to homeschool is a challenge, and it makes you greatly appreciate the people who teach for a living," observed the actor (pictured with her daughter, Marlowe). "They are making this system work in such an unpredictable and scary time. This experience is overwhelming, but I'm trying to bring in as much optimism as possible and make the most of the time I get to spend with my daughter. There's been lots of baking, lots of makeup, lots of swings."

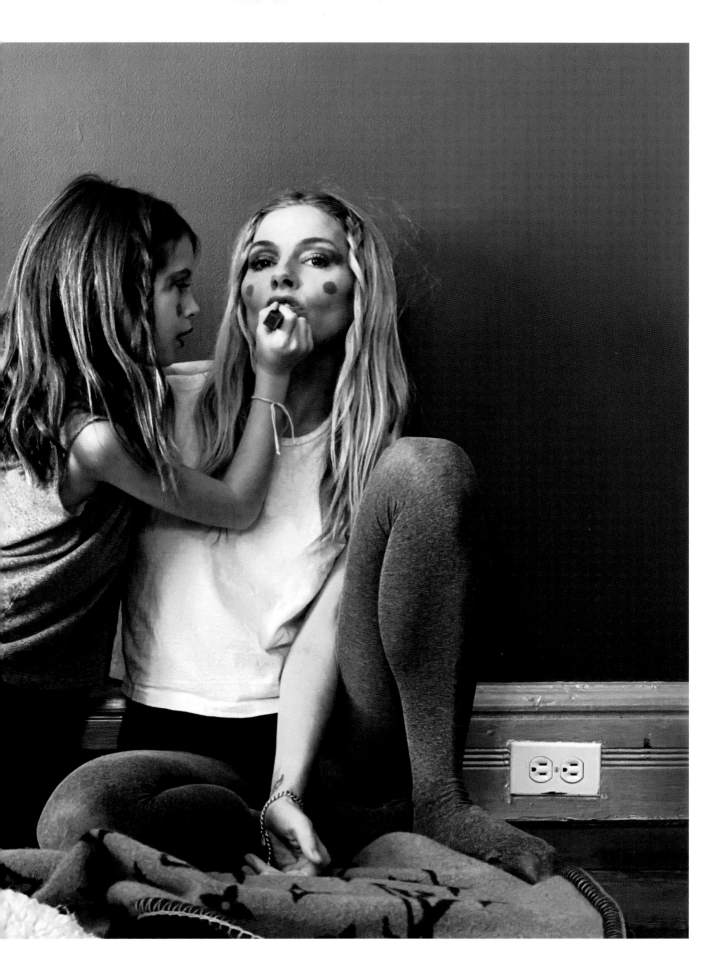

ALESSANDRO MICHELE, ROME

"I've rediscovered knitting and the sacredness of manual work," said the Gucci creative director. "I'm also learning how to play my classical guitar, feeling the connection with my dad's love for music. I'm aware of the privilege I have— I can slow down, while lots of other people are working tirelessly to help each and every one of us make it through these agonizing times. We would not be here, thinking about what this pandemic is teaching us, without their priceless effort. Some friends keep asking me: When will we go back to normal? I hope we will never go back to that 'normal.' From my windows, I can hear the birds singing as I've never heard before; seawater in Venice is clear once again. These are the little signs we need to look at once we go back to inhabiting this fragile world."

TIERNEY GEARON, LOS ANGELES
"All of my personal work is like a diary of my soul and my life," said the American photographer (pictured below, at far left). Drawn from an ongoing project, these pictures, taken with goddaughter Mia (in the red skirt) and Gearon's daughter Grace (on the following pages), play with childhood notions of structure and freedom. "The boxes, to me, represent boundaries," Gearon explained, "something I was not raised with."

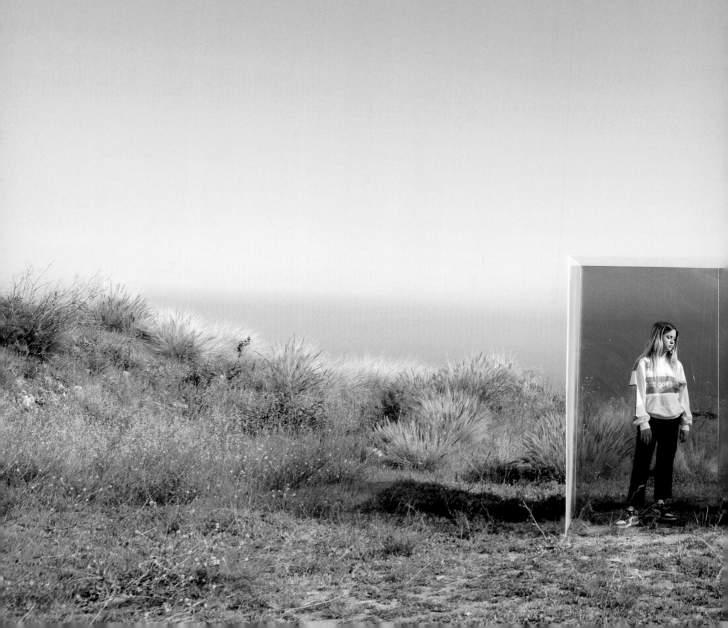

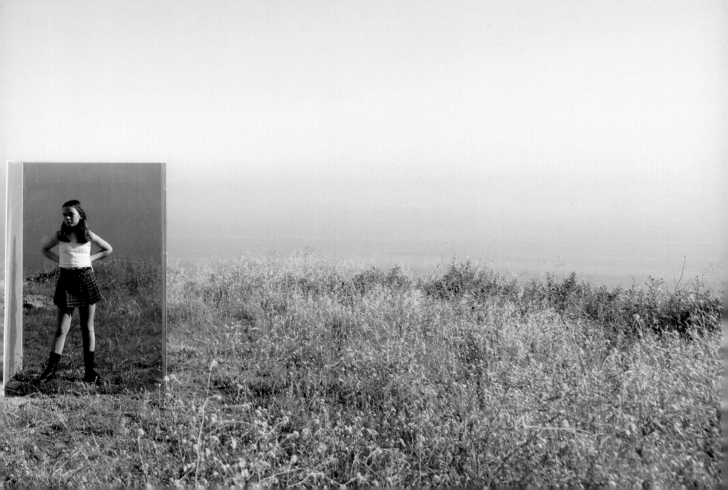

THE JOY OF COOKING?

By Hamish Bowles

When they closed both Mets in mid-March, a week or so ago, I knew that my days as a social butterfly were numbered, and with grim news from friends who were already expressly sequestered at home in Italy and France, I knew, as we all did, that life was about to change very muchly for *Vogue*'s much-traveled gadfly.

I'm lucky enough to have an apartment that was lovingly crafted for me by my great friends Roberto Peregalli and Laura Sartori Rimini of Studio Peregalli in Milan (where they are currently hunkered down under the strictest rules), but it was only during this past week or so that I realized that I haven't actually spent much time in it. In fact, I can count on one hand the nights I've dined in over the past year—and by "dined in" I mean "ordered in."

For an obsessively social person, out almost every night of the year, often in points exotic, this is clearly going to be a time for contemplation and recalibration.

Perhaps my new solitary life should begin in the kitchen, thought I. Painted an antebellum poison yellow, with Fez tiles underfoot, a scalloped pressed-glass shade overhead, and a series of technical drawings from a turn-of-the-century Cairene tentmaker on the walls, it certainly looks very pretty. It's a pocket-size Downton, and the redoubtable Mrs. (Beryl) Patmore would not be out of place here—although whilst she might recognize a pantry full of Worcester china, she would be baffled by both the batterie de cuisine and the contents of my fridge: a bottle of Ruinart (even though I haven't touched alcohol in nearly three years), Perrier and Evian bottles, probably rather stale chocolates, and a freezer full of 1930s hats (hopefully having any hint of moth frozen out of them).

I took myself to Whole Foods, which was confusing on every level. "Read the ingredients," a wise friend counseled—after I had returned. "Keep a running shopping list." Nevertheless, my fridge finally looked as though someone actually lived in the apartment. The freezer was stocked full too, but its actual use remained something of a mystery. It turns out I had a very hazy vision of how long it takes things to thaw. Several menus have had to be put off for a day.

I hied to my library of elegant cookbooks, none of which, it must be admitted, have ever been consulted by me for practical purposes. I thought that *Some Favorite Southern Recipes of The Duchess of Windsor,* 1942, might set the tone for elegant dining *à l'un,* but I wasn't in the mood for Virginia boiled tongue—and where would I find the ingredients for terrapin à la Maryland in the Washington Square Park vicinity? Next stop: *The Gay Cookbook— The Complete Compendium of Campy Cuisine and Menus for Men…or What Have You,* 1965, with chapters engagingly titled, "What to do with a tough piece of meat" and "canapes, hors d'oeuvres and aphrodisiacs." Although wildly amusing, I knew these wouldn't really help.

In desperation, I called Mum, the most practical and self-sufficient person I have ever known, who airily whips up a three-course meal for herself in minutes whilst regaling me with stories of her latest adventures and listening to Handel or Django Reinhardt. And when I say self-sufficient, I mean it: Before she was sequestered at home in leafy Twickenham, London, Mum was taking her transit van—kitted out inside with a perfect bohemian wagon interior, it has to be seen to be believed—to the countryside. She screeched the van to a halt at the sight of a freshly road-killed rabbit, skinned it by the roadside, flashlight held in her mouth, and had rabbit stew for dinner. Absolutely delicious, she assured me.

How she produced a son as effete as I is a conundrum that may never be resolved (although there is a clue). When she married my father, he didn't know how to boil a kettle or make a slice of toast, so she was determined to teach me some essential cooking skills. Alas, that was decades ago, and I have since been spoilt by a series of roommates, partners, and friends who have felt that my services as a sous-chef were generally more trouble than they were worth—not to mention hosts and hostesses who are whizzes in the kitchen (or who are lucky enough to have support teams who are). So the lessons evaporated.

HAMISH BOWLES is *Vogue*'s international editor at large.

The author, dressed for dinner *tout seul.*

The first challenge, to be brutally frank, was turning the oven on. In the first London apartment of my very own, I only ever used the cooker to store cashmeres, and in my first Manhattan place—a parlor floor in a stately brownstone on 13th Street—a friend coming to stay six months after I was first installed was nonplussed to discover that I had no idea whether my stove was gas or electric. When we finally figured it out and turned it on, there was an alarming smell before I realized that I'd put a stack of rare books in there for safekeeping.

I thought I'd finally managed to turn my cooker on, but something didn't smell quite right—in fact, there was a smell of something…dare I say, faintly gaseous? Moreover, after several minutes, the oven was stone cold. When I started fiddling with sundry knobs and opened the oven door, there was a God-almighty *whoosh* and roar, and my peroxide tips nearly went up in flames. Pilot light? Who knew?!

Somewhat chastened, I googled "How do I turn on my Bertazzoni oven?" For some reason, it corrected it to "range"—rude—but avuncular Chef Scotty gave me a

revelatory five-minute tutorial. "I need you to think like an Italian and sing to your stove," he counseled. "In the time that it takes you to sing one verse, the thermocouple will be warm enough." Now I break into a rousing chorus of "Dein Ist Mein Ganzes Herz" every time I turn the range on, and it seems to be doing the trick—although possibly not for my immediate neighbors.

I thought I'd start as I meant to go on. "I've got brussels sprouts and a salmon steak," I told Mum, now on speakerphone, and set about following her instructions to the letter.

"Don't forget my secret ingredient," said Mum, but before I heard what this could possibly be, I was assailed with the lovely aroma of woodsmoke—lovely for a second or two, and then a trifle baffling as I haven't lit a fire in years, and surely that wasn't what lightly sauteed garlic smelled like? In fact, my very nice Irish linen glass cloth—dangled insouciantly over the hob whilst I hung on Mum's every word—was up in flames. "Put it in the sink!" yelled Mum from the other side of the Atlantic. "Turn the tap on it!"

Baby steps.

CYNTHIA ERIVO, ATLANTA

"I'm still picking outfits that make me feel good—even if I'm just going downstairs," said the actor. "I'm still getting up and doing my little facial and skin-care regimen. I'm still wearing my jewelry because I love that, and it's a part of who I am.... So that stuff hasn't fallen by the wayside yet. I would say I'm staying fashionably cozy."

ASHLEY GRAHAM, NEBRASKA

"My husband, Justin, my son, and I have been here on my aunt's farm," said the model, who had recently given birth to Isaac (pictured on the following pages). "Being out here means so much to me. This is where I would come every summer to see my family and be with my cousins. The most important thing has been remembering to 'fear not.' Turn your TV off, get off social media, and remember not just to think positively but to speak it too."

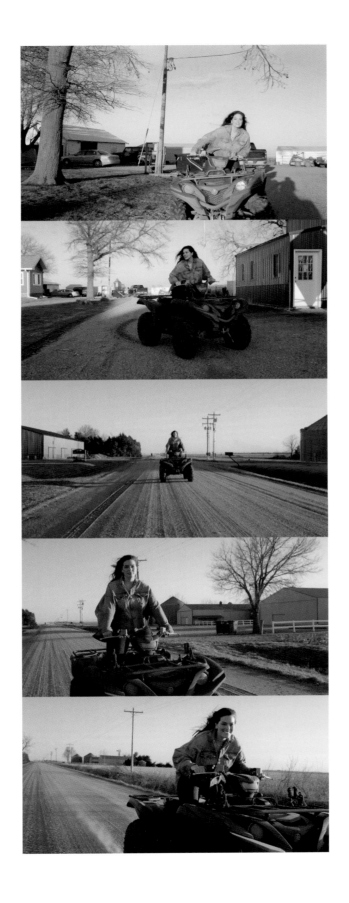

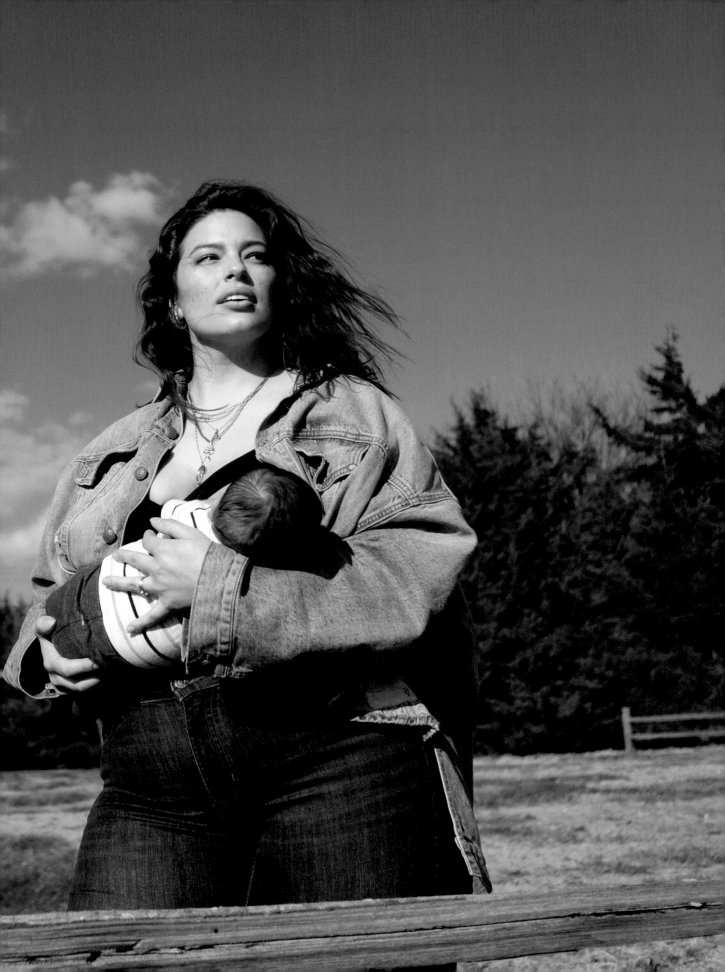

MARTIN PARR, BRISTOL, ENGLAND
"The newly invented currency which
is now part of the ongoing pandemic
is toilet paper," said the British
photographer. "The shelves had
been stripped bare of it, but I hit lucky
and got a multipack early on when
out at the local supermarket. So
this image is really a naughty boast,
the poor man's version of having
an expensive artwork on the wall."

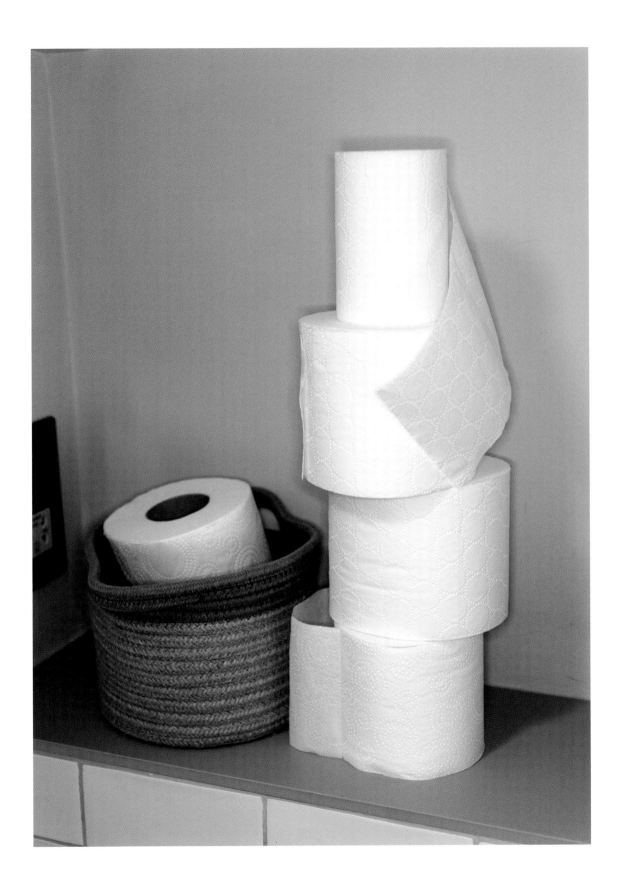

LIN-MANUEL MIRANDA, NEW YORK

"For me, the George Washington Bridge represents a constant in the face of a lot of uncertainty," the composer, lyricist, and actor said. "When I was a kid, I took piano lessons across the street from the building I live in now, and stepping out of the 181st Street train station, I remember the thing that blasted you was this incredible bridge that almost loomed over the street. And so it's been in my life for as long as I can remember. I'm looking at it now, and I think the only thing that's changed in the past month is the amount of traffic, which used to be legendary and has now slowed to a trickle."

MOTHER OF MINE

By Jessie Heyman

Before lockdown, I called my mother every day on my way to work. Instead of the traditional "Hello," she answers calls in medias res, her words pouring out in a thick Long Island accent: "I have been watching *Mad About You* all morning, and it's just so adorable. I just love this show! He's so adorable. Now *that's* the kind of guy you should be with. Do you like his looks? I think he's *gorgeous*. Do you ever watch this show? Everything is on this YouTube—it's so fantastic!"

I wait until the story exhausts itself—like watching a deflating balloon whirl around a room—before saying anything. These anecdotes, which range from something she heard on Rachel Maddow to the plotlines of schmaltzy sitcoms, last only about 30 seconds, but by the time she's finished, I'm fully annoyed. The rest of our conversation is brief and perfunctory: work, weather, my plans for that night. The conversation is over in under three minutes. "All right," I say, cutting it short. "I love you."

When I was younger, I would call my mother my best friend. I thought she was beautiful and funny and *fun*. Thinking back, I find her permissive parenting style shocking: When I didn't feel like going to school, she'd lie to my teachers and tell them I was sick. Sometimes I'd skip class and we'd spend the day at the mall. She'd let me have friends over in the middle of the night; she'd let me have boys over whenever I wanted. She'd curse and make dirty jokes. She was a cool mom, and I felt lucky she was mine.

As I got older, I would say that we were *close*—a euphemism for a complicated relationship. But it was also technically true; according to my call log, we were *very* close. Whenever my brother and I would talk seriously about Mom—about her latest work drama or car accident or money issue—I would find myself citing these daily calls as proof of my daughterly devotion. "We need to plug into her life," my brother would say. "What more can I do?" I'd respond. "I talk to her *constantly*."

I started taking care of my mother when I was in high school. Our role reversal was so pronounced that sometimes—when she asked for a glass of water before bed, or when I reminded her to tell me if she was going to be out late—she would call me "Ma." Our dynamic didn't bother me; I recognized it as unusual, not problematic—an inside joke between the two of us.

Things got more serious when I went to college. When I was 21, my father died and all my mother could provide was off-color humor. "Aren't you a little relieved?" she said later that night with a crooked smile. She always treated my dad—a complicated figure who was in and out of my life—with mockery and dark humor. Maybe she was just trying to break the tension, to absorb the shock of a sudden death. But for the first time, the joke wasn't funny anymore.

The space between my mother and me continued to grow. As I became more serious—about my work, about my relationships, about the quality of my life—she became sillier, hoping, perhaps, that I would snap out of the rigidity of adulthood. She mourned the messy girl I left behind—"You're so *uptight!*" she'd yell—but also marveled at my transformation.

"You are absolutely incredible," she'd say after I told her I was on my way to work. "I don't know how you get up every single day and go to work this early. You really are fantastic." Her awe infuriated me. "Mom," I'd say in a cold, clipped tone, "it is not exceptional to go to work at 9:30 in the morning." She'd laugh: "Well, it is for me!"

The jobs that have worked for my mother played to her strengths: socially driven sales roles with very little structure. She was always the most popular person on the floor, but she invariably found herself in trouble—scheduling mishaps, dubious discounts for her favorite customers. After she was let go, it was almost always met with relief. "Honestly," she'd say, "I hated that fucking place."

In my mother's mind, we are always on the precipice of *something great*. She was counting on the next thing—an amazing job, a beautiful apartment, a perfect relationship. "I just *feel* it," she'd say to me. "You have no idea how special and fantastic you are. Just you wait and see, we'll be laughing about this in a few months." When I was young, I relied on her irrepressible optimism and lavish praise, but now they took on a kind of tragic color. I could no longer countenance her reckless dreaming; I'd respond only with eye rolls and icy logic.

JESSIE HEYMAN is the executive editor of Vogue.com.

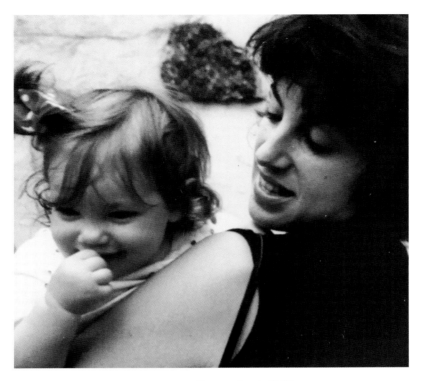

The author and her mother in 1988.

When the coronavirus hit, I worried most of all for my mother, who lives alone in a small studio in Westchester. She's a bit like a child: She hugs freely, trusts instinctively. I felt she lacked the organization to follow the new health guidelines. *Is she washing her hands for the full 20 seconds? Is she wiping down her groceries properly? How will she even get groceries?*

We figured out the logistics fairly easily. My brother helped her navigate the bureaucracy of applying for stimulus payments and unemployment, and I was responsible for arranging her food deliveries. The onslaught of bad news, the indefinite timeline, the absence of silver linings, however, was harder to handle.

My initial attempts to help came off as schoolmarmish: I scolded her for sleeping in, for staying up late, for not making herself proper dinners. "This is not vacation," I said a few weeks into quarantine. "This is real life. You will surprise yourself with how much better you feel when you wake up every morning and have a plan for your day."

She said she would try to be better. I hung up the phone, but I couldn't shake the sadness I felt. A short while later, I called her back. "Don't worry, baby," she said. "I love you no matter what." That afternoon, she texted me a photo of the oatmeal raisin cookies she made. "I'm practicing to be a good grandma!"

At the end of April, my sister-in-law had a baby. The night before my nephew was born, my mother and I spent hours on the phone—picturing the baby's face, how my brother would be as a father, and how excited we were to one day meet this new person. She texted me her favorite photos of us as kids. I entertained her stream of questions: "Do you think he will have curly hair? Will Yana like breastfeeding? What do you think the baby's cry will sound like?"

We kept dreaming out loud—and, for the first time in a long time, I didn't mind. Much has been written about the return of the phone call, but for my mother and me, quarantine didn't change the amount we spoke—but rather the *way* in which we communicated. Our lives suddenly looked similar: both of us living alone, grappling with an unsettling new reality. In the absence of status updates, our talks shifted to our emotions—complicated and honest.

It was well after midnight, and the conversation turned to me: which baby names I liked, how I'd be as a mom. Like always, she went on for a while, but I liked listening to her tell this story. I've long seen the effect my mom has had on other people—how happy and loved and seen they feel when she's around. I felt myself softening, and for a brief moment, the outside world seemed very far away. "You know, being able to talk to you like this," my mother said, "is the best part of this fucking virus."

TYLER MITCHELL, NEW YORK

"I took this image when I was in a moment of despair about the world, to be honest," the photographer said. "So the idea of getting dressed up or taking a 'fun' selfie with fashion wasn't exciting me. But I was really into the foot-on-the-world graphic on my T-shirt, which is from Monty Python. I feel it nicely summed up the state of things."

HARLEY WEIR, LONDON

"Our favorite place," wrote the British-born photographer (left), pictured at home with painter George Rouy.

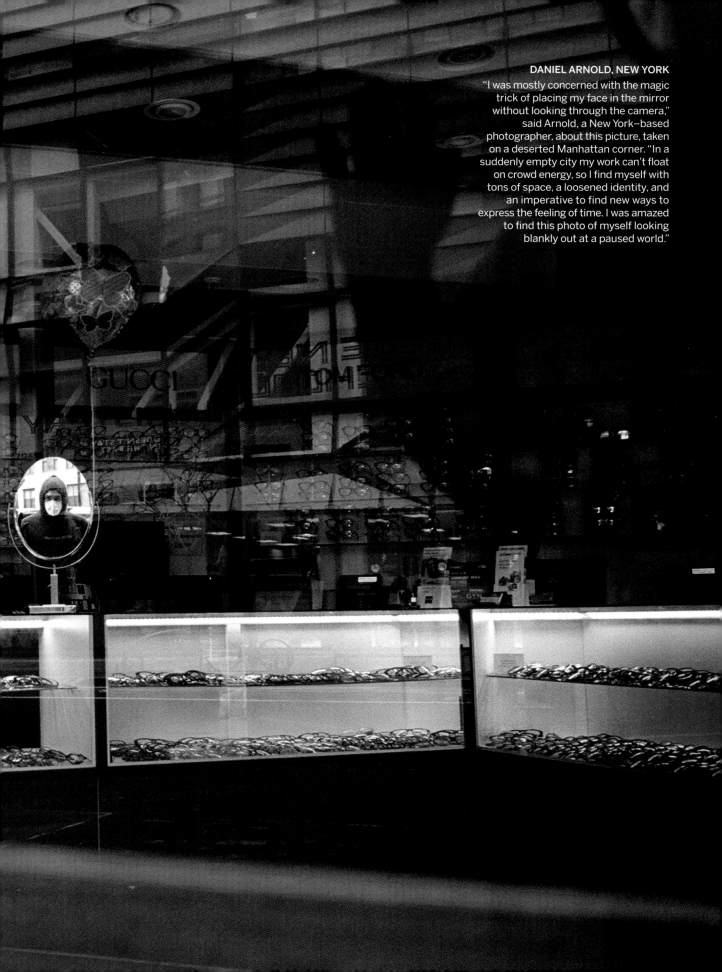

DANIEL ARNOLD, NEW YORK

"I was mostly concerned with the magic trick of placing my face in the mirror without looking through the camera," said Arnold, a New York–based photographer, about this picture, taken on a deserted Manhattan corner. "In a suddenly empty city my work can't float on crowd energy, so I find myself with tons of space, a loosened identity, and an imperative to find new ways to express the feeling of time. I was amazed to find this photo of myself looking blankly out at a paused world."

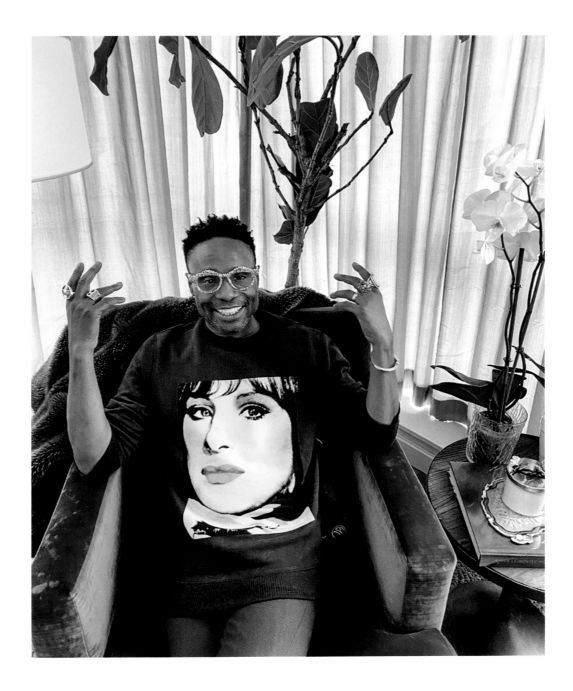

TORY BURCH, NEW YORK

"The irony is we are at a kitchen table again—that's where everything started for us," the designer said. "This is a window into my day right now: strategizing and meetings from eight to eight (there are only a few places where we have wireless service). But it's hard to balance that with the emotional part of what we are going through; it's heartbreaking. I lost someone very dear to me. It's a roller coaster of emotions. As someone who is naturally more optimistic, though, I have a lot of faith in humankind. I say to my kids, If now is not the time to appreciate what we have, when is?"

BILLY PORTER, LONG ISLAND, NEW YORK

"Barbra Streisand is someone I always turn to when I'm looking for joy," the actor said. "Her singing 'When the Sun Comes Out' in one of her old black-and-white television specials is still *beyond*. I'm also working on the first draft of my memoir, I've just been hired to rework a musical, and I have new music coming out—so I got a lotta shit to do. But being with my husband is the biggest source of joy right now. We haven't had a lot of time together this past year, so it's been really great to just be with him and love on each other. I'm using this time to focus on that and not let the fear and the panic of the moment paralyze me."

CAMILLA NICKERSON, UPSTATE NEW YORK

"Time has taken on a whole new meaning, shape, and form as hours, days, and weeks seem to roll like the hills here," said *Vogue*'s style director from her home in upstate New York. On the opposite page is "a T-shirt I was given a long time ago when we built the home that is now our shelter, for which I am very grateful," she continued. "I find that remembering to take things one day at a time is calming and centering. I wake up before dawn each day, as seeing the sunrise brings me hope and strength. That's when I took this picture."

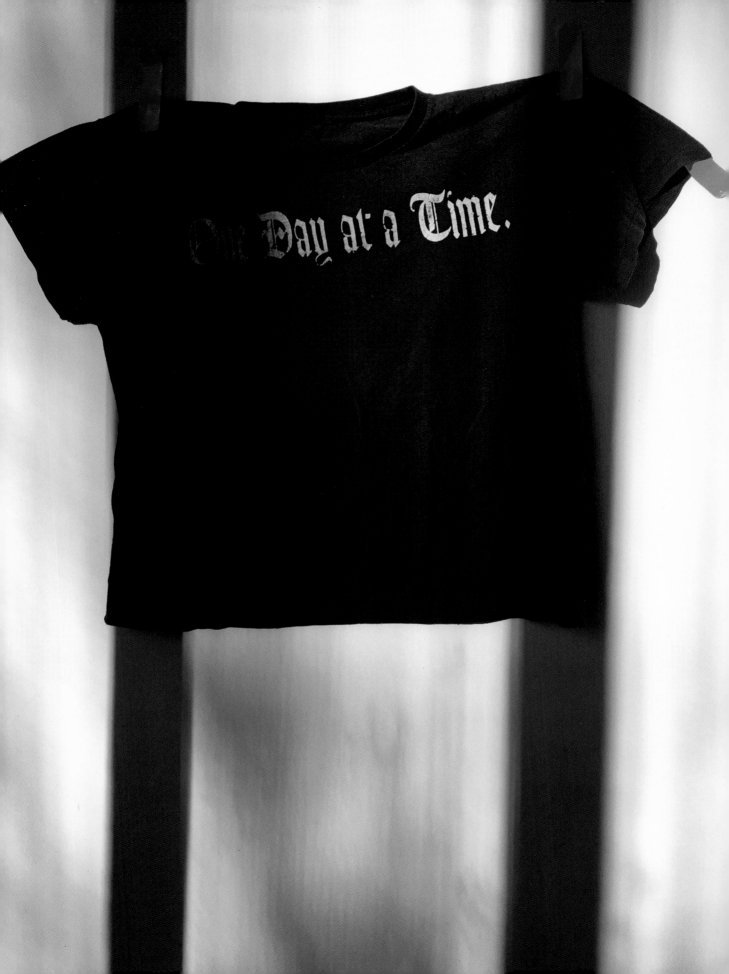

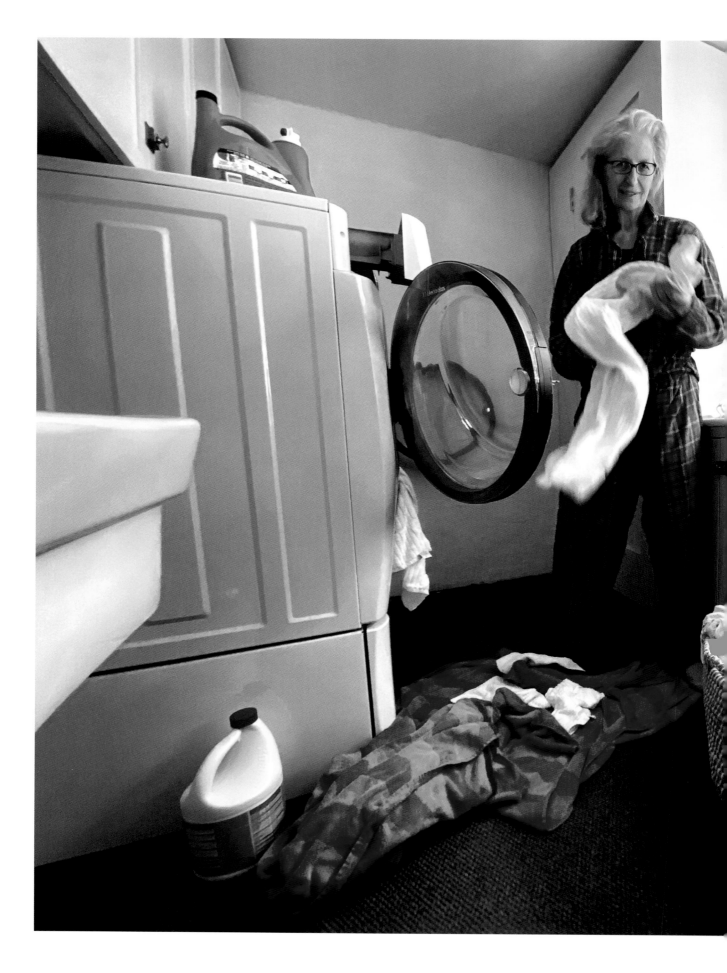

**ANNIE LEIBOVITZ,
UPSTATE NEW YORK**

"All I'm doing is laundry
and cleaning and trying
to figure out meals,"
the photographer (and
mother to three teenage
girls) said. "I'm living
in these old pajamas."

DRAMATIC WARM

STEVEN KLEIN, LONG ISLAND, NEW YORK

The American photographer captured his
four-year-old son, Ace, surrounded by a plush
menagerie. "The future of the planet is the
children," Klein wrote. "What a mess we made of it."

ADUT AKECH, ADELAIDE, AUSTRALIA

"I was supposed to come see my family in Adelaide for a week, and now I've been home for a month—but I'm grateful to be stuck here," the model said. "I couldn't imagine being anywhere else. I've been staying positive by exercising and meditating as much as possible, and I've been making my siblings (pictured) join me, just to make sure their immunities are strong and healthy. I've also done a lot of reading, which has been good for my mental health."

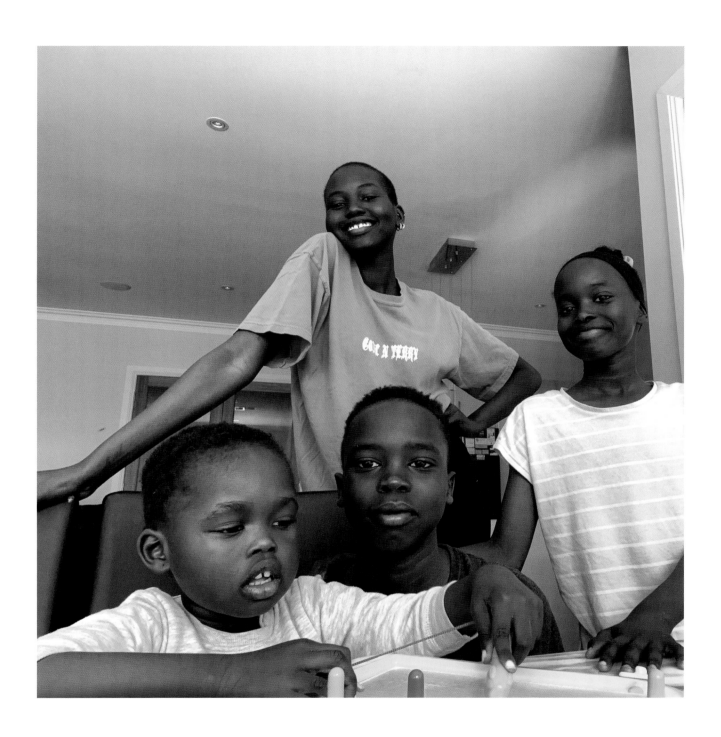

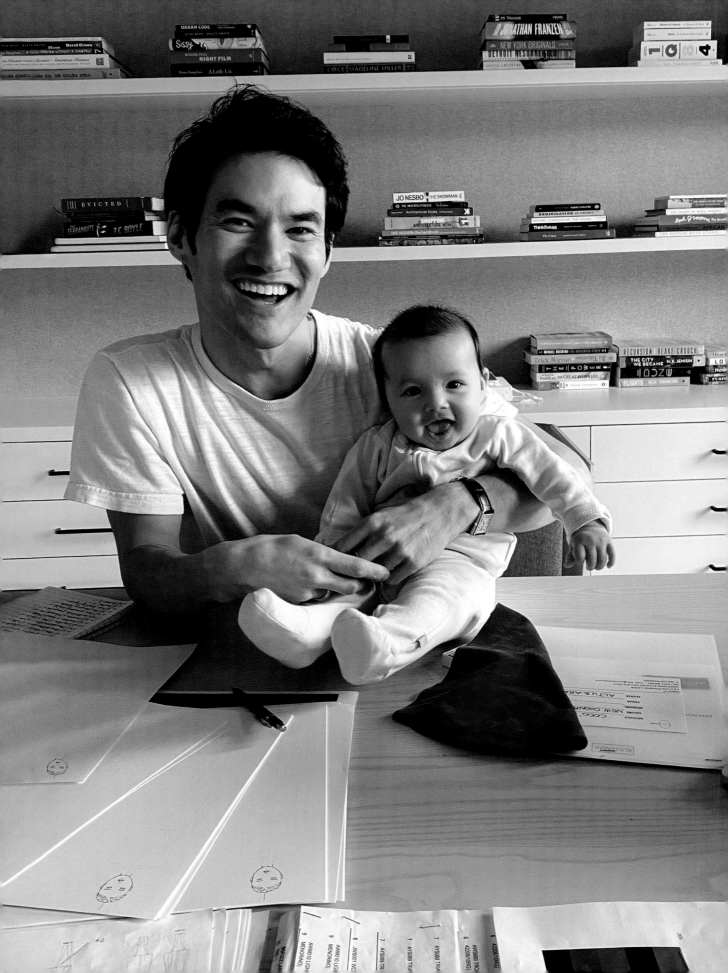

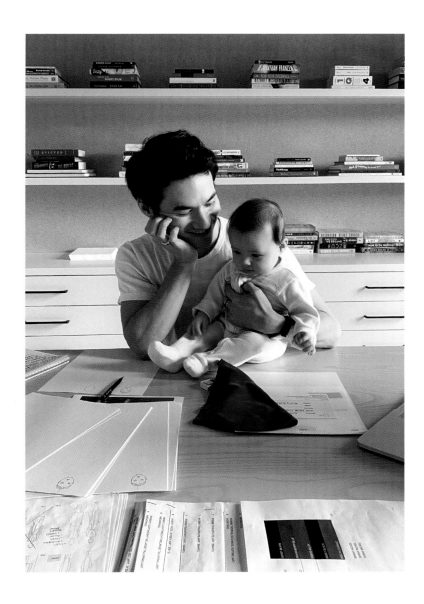

JOSEPH ALTUZARRA, LONG ISLAND, NEW YORK

"I have an office right next to the nursery in our house, so I see our daughter, Emma, all day long," the designer said. "My husband, Seth, and I are figuring out how to be parents and run our businesses remotely. I have a Zoom meeting and I will hear her crying—and then she's on my lap. My personal and professional lives are more intertwined than they've ever been. It's been an incredible bonding moment for our family, and I am trying to see this as a silver lining. She is a very happy baby."

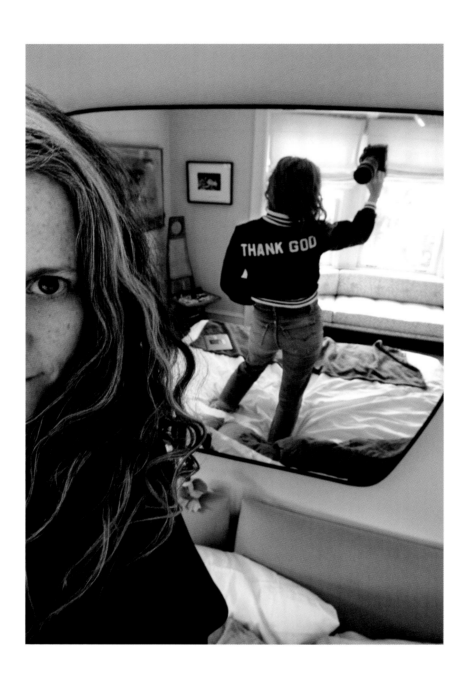

CASS BIRD, NEW YORK

Asked what is keeping her calm and collected right now, the photographer—pictured on the opposite page with her son, Leo—replied: "Going back to basics. Home, nature, being in the day."

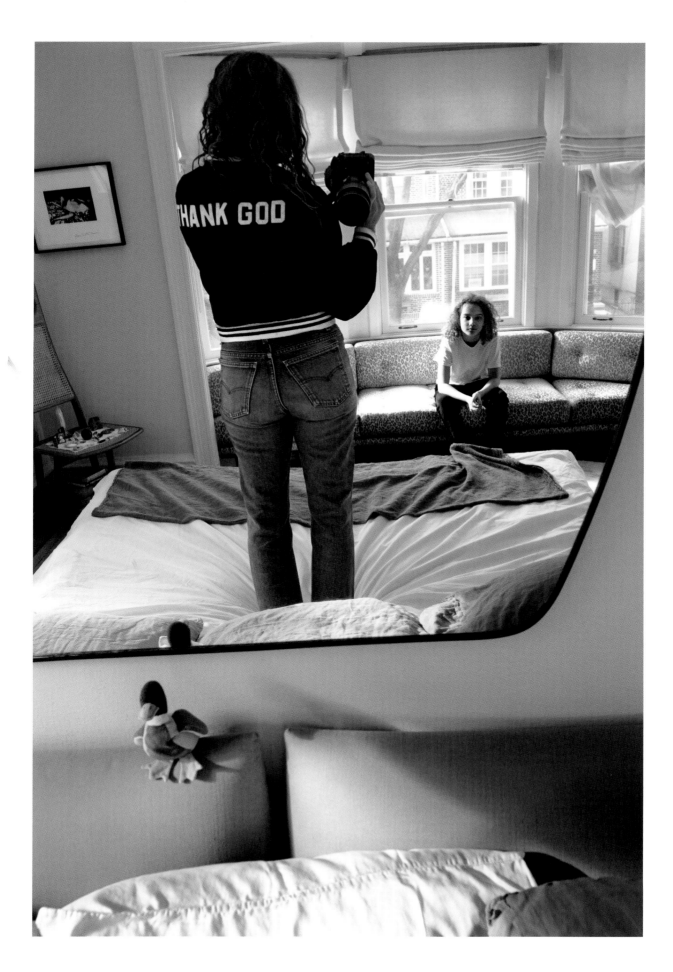

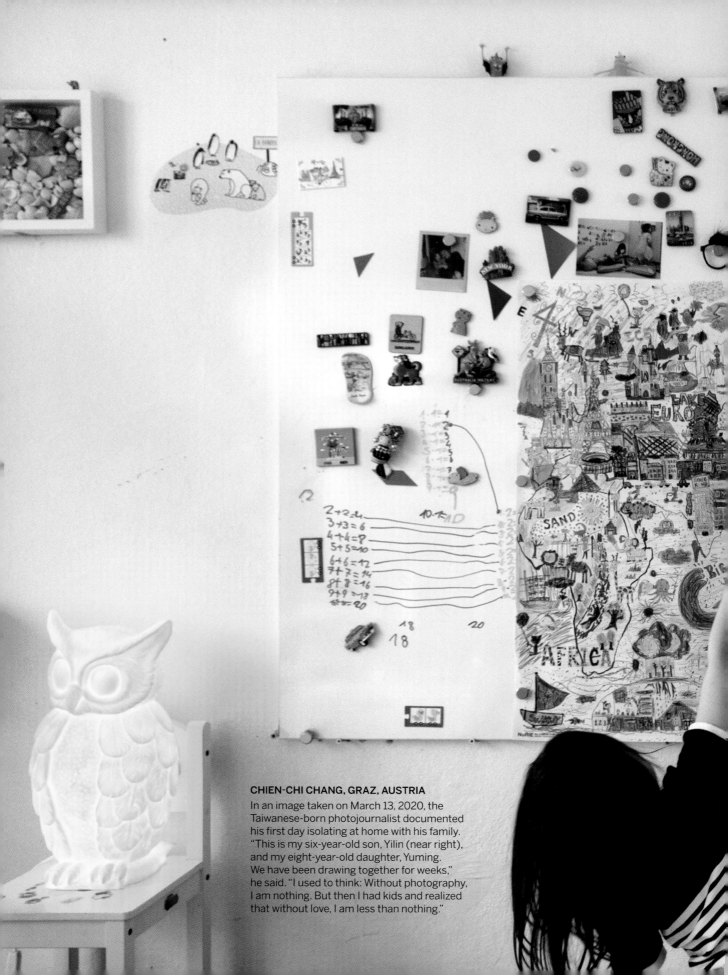

CHIEN-CHI CHANG, GRAZ, AUSTRIA
In an image taken on March 13, 2020, the Taiwanese-born photojournalist documented his first day isolating at home with his family. "This is my six-year-old son, Yilin (near right), and my eight-year-old daughter, Yuming. We have been drawing together for weeks," he said. "I used to think: Without photography, I am nothing. But then I had kids and realized that without love, I am less than nothing."

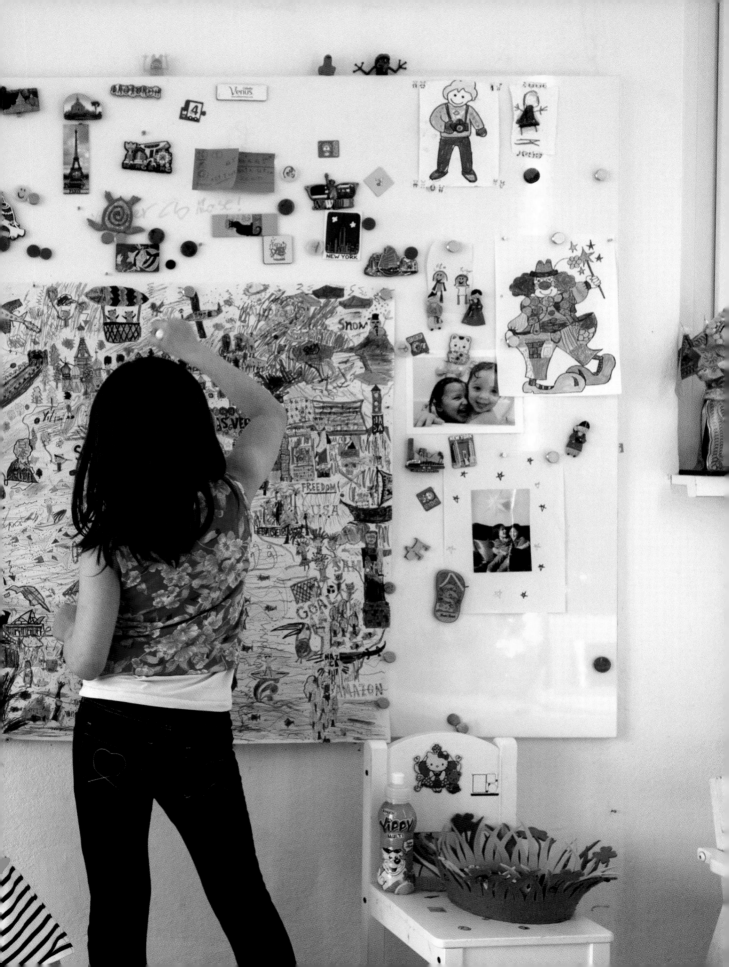

THE KIDS ARE NOT ALRIGHT

By Taylor Antrim

My daughter disappeared into a room yesterday. My wife and I noticed—*of course* we noticed. We've never been more aware of the whereabouts of our children: Vivian, seven; William, five. They are omnipresent, clamoring for our attention. Who else are they going to clamor for? We are all confined to our home. We are all going crazy.

Also: My wife and I are healthy. We are safe. We are in a house outside New York City, not in our cramped Brooklyn apartment. Gratitude and perspective have never been more important than right now, and, reading the news, seeing pictures of overwhelmed hospitals, I am aware of how much I have to be grateful for.

But I don't want to sugarcoat this: We are *going crazy*. And not just us. It's fascinating to see the ways confined people are cracking up, whether it be Anthony Hopkins, that Israeli mom, or Layla who can't get her Nando's. You may suspect you're sick, or be suffering from isolation, or be fearful for a loved one, or you may be crazy for the simple reason that my wife and I are crazy. You're working from home and you have young children.

That's a recipe for insanity, my friends. My job at *Vogue* keeps me hopping between Zoom meetings, connecting with colleagues and writers, editing stories, keeping up with email. My wife is a high school teacher conducting Zoom classes with her students at least twice a day, prepping for said classes, joining faculty Zoom meetings, grading papers. Meanwhile, my daughter is in second grade and my son is in preschool. Can they teach themselves to read and do subtraction and build stuffed-animal homes from recycled materials and construct obstacle courses and learn about change-makers all on their own? They cannot. Did I mention that we have a dog who needs to be walked?

My wife and I have held it together through steely will and daily schedules composed with military precision and taped to the kitchen counter every morning at 7 a.m. And no, we are not shy with screen time. After a certain hour of the day, the kids are allowed to sit two inches from a big TV. Later in the evening there is *Love Island Australia* and knitting; there is *Better Call Saul* and gin.

How are the *kids* coping? That's what my relatives want to know. And they're right to wonder. The emotional life of a child during a crisis like this is so hard to fathom. My son had a Zoom with his preschool class, and the teacher asked them all to say how they were feeling. I listened attentively, but they all basically said the same thing: Happy! They were happy. I smiled, profoundly relieved. William *seems* okay. He talks wistfully to me about when he will see his friends again, he burst into tears thinking of the stuffed animals left in our Brooklyn apartment, and he complained just this morning that Mom and Dad are working too much. But basically, he's five. He plows ahead, searching for the next snack.

A seven-year-old is a more complicated case. The other day, without warning or any preparation from us, Vivian used the word *coronavirus* in a sentence. A sweet-hearted girl, she has recently been boiling with feeling: bouts of manic energy, displays of hypercompetitiveness, hysterical tears at irrational moments, all while maintaining a prevailing cool-girl pose that feels like attitude but I suspect is a kind of sublimated anger. Her birthday is Sunday. We were going to take her and three friends to a Korean spa.

TAYLOR ANTRIM is the executive editor of *Vogue*.

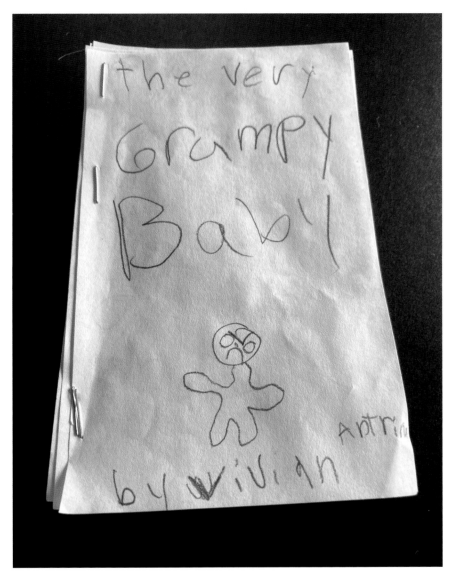

Quarantine fiction by the author's daughter.

Instead, we will be making her a sheet cake. If there's any cake mix left at the supermarket.

She's going through something, in other words.

And as I said, the other day she disappeared into a room.

Here's what she emerged with: a small, handmade book (five pages, stapled together). The title: *The Very Grumpy Baby*. It's a parable of madness.

In it, a couple gives birth to a grumpy baby. A baby who never smiles. A baby, she writes, who says, "I want to be evil." On page two the parents consult a doctor. The baby is not sick, the doctor says. The baby simply doesn't smile.

But the parents continue to worry about their baby. By page three they have come up with a plan. They will *themselves* refrain from smiling. They will be as grumpy as their grumpy baby. After a week of this, the baby smiles. The end.

Do you find this as chilling as I do? My wife and I maintain that we will all look back on this period with rose-colored glasses, remembering the family time, the craft projects, the jolly dinners. We will laugh about it and reminisce and long for more togetherness. But that is not where we are. Right now we are here. Together. Wondering just how much longer this is going to last.

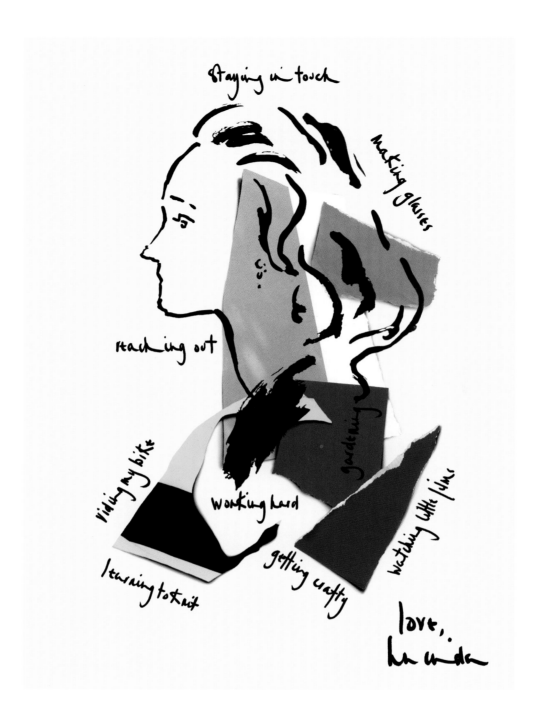

LUCINDA CHAMBERS, LONDON

"I've literally never done a selfie in my life, and I didn't think I wanted to start practicing on American *Vogue*," said the editor and stylist. "So I took an old sketch Clym Evernden did [of me] at a party, and I asked artist Anna Bu Kliewer if she could cut out some things to make it look three-dimensional and bring it to life in a collage. And then I just wrote all my bits and bobs on it—a shopping list to myself of what this time means."

YOON YOUNG BAE, SEOUL

"I am in my hometown in South Korea with my sister, YoonJi," said the model (near right). "Every day I spend time with my family at home, doing some personal training, cooking, eating, and gaming—here we're playing Animal Crossing on Nintendo Switch. You can communicate with villagers, decorate, and earn money by fishing or catching insects."

HASSAN HAJJAJ, LONDON

"Home safe" in the U.K. with his family (pictured here and on the preceding pages), the Moroccan-born photographer rendered life under lockdown in poetic terms: "What was important yesterday seems like a dream today. What is important today seemed like a dream yesterday. What is important tomorrow seems like a dream today. What is important today is a dream for tomorrow."

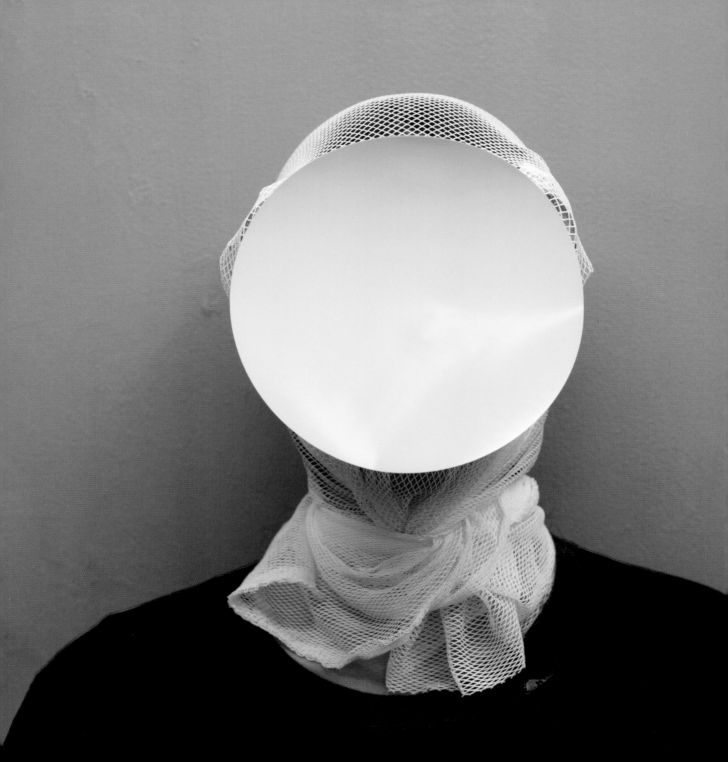

JACKIE NICKERSON, COUNTY LOUTH, IRELAND
"I'm wearing things that I made, things that perhaps reflect how insular our lives have become," the Boston-born photographer said from her studio in rural Ireland. "The image with the yellow circle is an homage to the late, great conceptual artist John Baldessari. He used appropriated imagery and applied colorful dots to photos. The yellow dot in this photograph is real, not added later. Both images use material that is meshed, that has a netting effect. The pink is a mixed jersey nylon material, and the other is brown Geami packaging paper." Her costume on the following pages was inspired by the sea: An iridescent material found in Los Angeles "reminded me of fish scales," she said, and the seaweed-like "green plastic stuff" came from "a commercial vegetable farm in Spain."

KENDALL JENNER, LOS ANGELES

"This is my happy place, reading in my home in front of my new James Turrell piece that I'm very proud of," the model said. "Turrell is an artist I've wanted in my home for a long time, not only for the beauty of his work but for the purpose. His pieces are meant to be meditative. They make me feel calm and help put my mind at ease—I'm usually listening to one of the many ambient playlists I have. I believe, especially in the current climate, that keeping a good mental state is important. Identify all the little things that mean the most to you, and embrace them."

COLLIER SCHORR, NEW YORK

"My favorite camera, the Leica M10, is in the picture, but this is shot with the iPhone 11 Pro. That way I could see my own face," the photographer explained of her selfie, taken in the bedroom of her Williamsburg apartment. "I was trying to make a photo with Olivia Galov, who I am quarantining with, to have a self-portrait that engages the idea of photographing someone else."

VIVIEN SOLARI, HAMPSHIRE, ENGLAND

"I am spending lots of time in my garden whilst in lockdown," said the model, seen with her dog, Dougie. "I strive to live a sustainable life, and growing some of my own fruit, vegetables, and flowers is a part of that. My three children love being outside with me and sometimes get involved with the growing. Having 10 minutes to sit outside in the garden, listening to the birds and reading with a cup of tea, helps me switch off for a moment. I find when life is busy, it's also easy to pick up poetry and be transported."

CAMERON RUSSELL, NEW YORK

"My mom knit this sweater for my son, Asa," the model said. "She frequently salvages and repairs handmade sweaters and quilts from a thrift shop. Since I was little, she'd let us flip through her design books and choose patterns for next year's sweater. Now these are the stories I think about when I consider what the future of fashion might be. Making fashion less consumerist and more sustainable means remembering fashion isn't just about buying things; it's also about community, culture, and creativity. It's about sharing and repurposing, making and mending."

ABBY CHAMPION, LOS ANGELES

"Right now, I think it's imperative to connect with parts of yourself that you haven't before, and reconnect with things that you love," said the model, seen with her dog, Champ.

TESSA THOMPSON, LOS ANGELES

"I've become really aware of waste in a way I wasn't before," said the actor, pictured with her dog, Coltrane. "I'm so much more mindful of what I consume, and that's something I want to take into life after this. When I take a walk in my neighborhood in L.A., I've never felt the air this clear, and I know it has to do with there being fewer people on the roads. There is something really important about that. I think we will need to look back at this time and remember this."

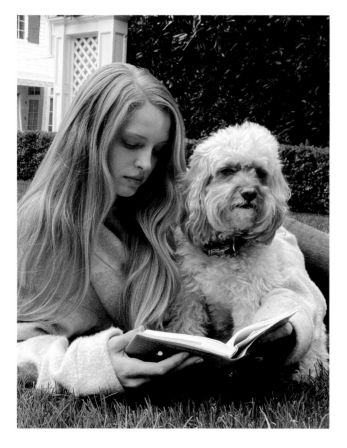

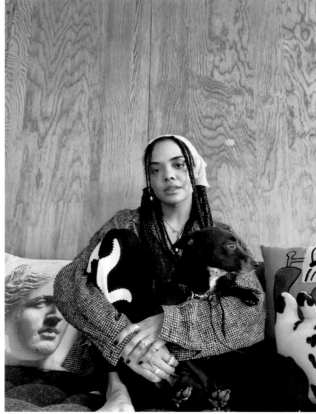

FRAN SUMMERS, YORKSHIRE, ENGLAND

"I'm very glad to be around my family during this scary time," said the model, captured with her father, Keith, and their dog, Oscar. "If this awful experience has brought anything to people, it's an awareness of our humanity and [the importance of] human kindness."

CHUNJIE LIU, JIAXING, CHINA

"When I first landed in China, I was quarantined in a hotel for 14 days," the model said. "Luckily, it was close to my home, so my mother left meals for me every day. The first thing I did when the two weeks were over was hug her and, of course, my dog, QuiQui."

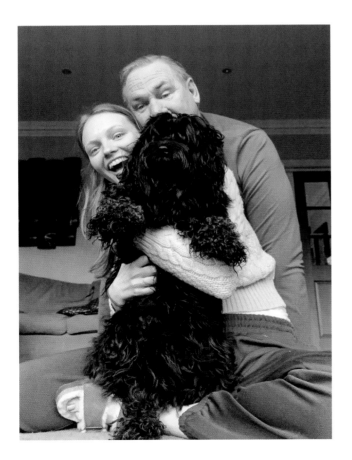

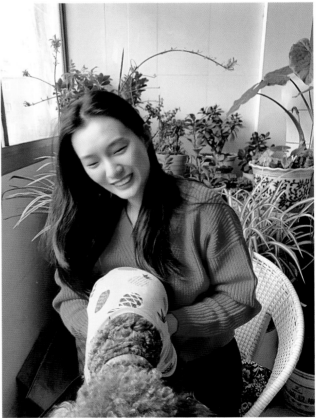

**NICOLAS GHESQUIÈRE,
YVELINES, FRANCE**

"I am quarantined outside Paris, in my home in the countryside," said the Louis Vuitton creative director, pictured with his dog, Leon. "The framed image in the background is very special to me—it is a photo of Cate Blanchett as Queen Elizabeth I of England, shot by Irving Penn and wearing a look I designed for an editorial project with *Vogue*. What gives me hope? The perspective of a brighter future, with even more consciousness infused into the fashion industry. This time of crisis has awakened each of us to different ways of working together more responsibly."

HYUNJI SHIN, SEOUL

"Now that I am home, I get to spend so much time with my 'son,' Mango, napping, playing, and going on short walks," the model said. "I'm also teaching him to do tricks like sit, shake, and high-five. He's an okay student—it's a work in progress."

**AMANDA HARLECH,
SHROPSHIRE, ENGLAND**

"I love reading in my music room, and my lurcher, Albertine, makes a point of taking up as much of the sofa as possible," the creative consultant said. "Up till now, I have always been on the move, traveling to Paris or Rome or New York...but elsewhere was a constant. Spring under COVID-19 has meant lockdown, but also a time to unlock all the books I have wanted to read."

RYAN MCGINLEY, NEW YORK

"My dog, Dickie, and I were trying to highlight the importance of wearing masks in an effort to reduce the risk of contracting the coronavirus," said the photographer. "I put a bandanna across his face to give the photo a sense of humor, which is needed during these challenging times."

TINA BARNEY, RHODE ISLAND

"I've been making works on paper from my own photographs and snapshots since the 1990s," said the photographer. "I thought this would be fun and more gratifying than just taking a selfie with an iPhone."

ENRI CANAJ, ATHENS

"A few days after the lockdown,
I spotted a man selling fresh
fruits on an empty street," said
the Albanian-born photographer.
"'I've got to earn my living, son,'
he said when I approached him.
'There's nothing else I can do...at
least I've the mask to protect
me.' I felt like I captured the visible
part of a situation that was
suddenly becoming invisible."

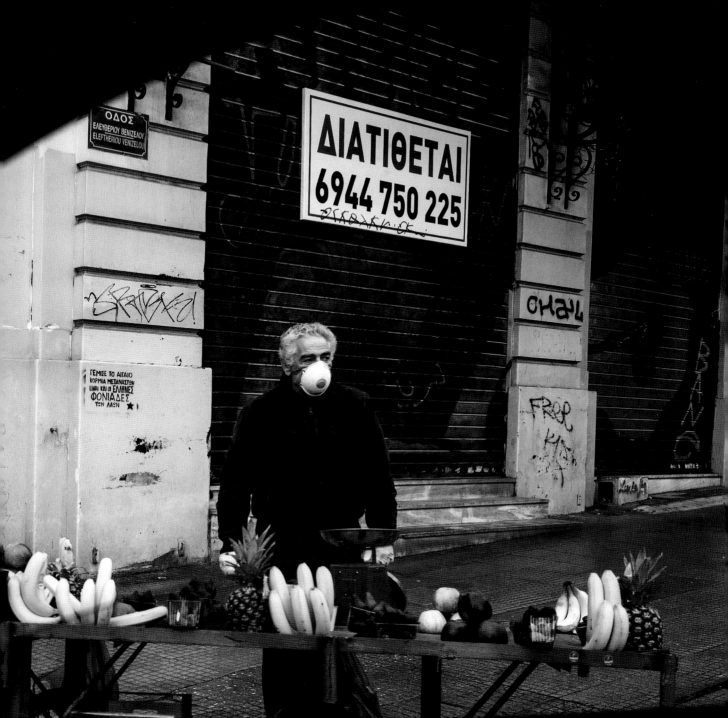

HOUSE PARTY

By Chloe Schama

My parents live about 30 miles north of Manhattan in the house where I grew up—two big glass boxes, linked by a smaller glass box, all of it overlooking the Hudson Valley. It was built in the 1970s by an advertising executive who somehow got custody of his four children. He lived in one box; the kids lived in the other, each with their own tiny bedroom. If separation was the first organizing principle of the house, transparency seemed to be the slightly contradictory second. Two-story windows make up the western wall of the living room; a balcony runs almost the entire length of the second floor. On sunny afternoons the house is blindingly bright; in storms, it feels like a ship at sea, battered from all directions. Inside, every noise echoes; on the second floor, you can hear conversations taking place in the basement.

When people visit for the first time, they sometimes make comparisons to a treehouse, an impression caused by the drop at the rear—a steep descent of about a hundred feet to where the land levels off into a boggy marsh. A dozen years ago my parents discovered just how precipitous this construction was. The house, a well-meaning contractor told them, was one large dinner party away from crumbling into the valley below, thanks to industrious carpenter ants that had reduced the cross beams to delicate doilies. But after a massive repair job, it's still standing.

I lived here from age 10 through 18, returning after college and then the summer after I quit my first job. Before I headed to grad school, I deposited a dozen boxes of books in my parents' garage; and then when I left school with a degree that no one understood (a master's of philosophy in criticism and culture), I went back to the house to try to sort out my life and those boxes of books. As much as I loved it there, I thought of these visits as way stations on a path toward a more autonomous future, toward life on my own terms. But now I'm back, and I'm not sure when I'm leaving.

My alarm goes off at 5:45 every morning. If I'm lucky, I can get downstairs before anyone is awake and enjoy four and a half minutes of silence and solitude in the predawn dark, though there are a lot of potential early-morning companions because my husband and I, my three children (ages six, four, and two), and our au pair are all here now.

We arrived about four weeks into the coronavirus crisis, when the ambulance sirens wailing down the streets of Brooklyn seemed to sound out every five minutes, but also after we had spent sufficient time sequestered that we felt relatively sure we were not infected ourselves. (Both my parents are in their mid-70s, healthy but at risk.) Before we departed the city, I kept texting my mom: *Do you have enough sponges? How is your supply of canned tomatoes? Do you need us to bring toilet paper? Laundry detergent?* But it wasn't about the sponges. Our Brooklyn furniture, castoffs from my parents, is covered in handprints, magic-marker dots and dashes, color-field swatches of spilled juice. Because my kids are so evenly spaced in age, I can keep a pile of trickle-down footwear on the front porch—a size for anyone. When you walk in, it looks like we're running a day care. We are a family of flailing limbs, temper tantrums, and kids who scream "super-speed" whenever they eject themselves from a room. We take up a lot of space, and we leave destruction in our wake.

When we first arrived, my parents met us at the door, welcoming, smiling sentries. We had all been cooped up, and there was a fiesta energy in the air. We made it! Camparis all around! But the journey was much less of a feat than it regularly is. We glided through the Battery Tunnel with not a single car in sight, as though trapped in a meditative video game. *Mommy's office,* my kids cried when we emerged, as they do every time we pass the World Trade Center, and I said, *Yeah,* with less enthusiasm than usual, because I wondered if it *is* still mine. What tense do we use now to describe our strangely past-and-present life? We flew up the West Side Highway, past the hospital ship, past

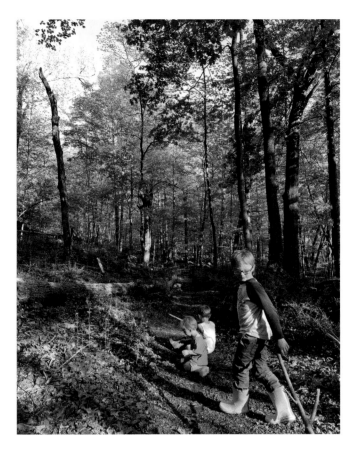

The author's three young sons on a walk in the woods.

the George Washington Bridge, onto the stomach-bending curves of the Saw Mill Parkway. It turns out we live only 55 minutes from my parents when the roads turn into a desolate passage north.

In the days that followed, we settled into something like a routine. After my four and a half minutes of early morning peace, I escape for a run and my husband is in charge of supervising our kids' daily *Paw Patrol* viewing session (screen-time rules a distant memory). When I return, I find my mother and father sitting at the kitchen table in their dressing gowns, a pot of tea in front of each of them, hiding behind sections of the newspaper. Meanwhile, my kids fling Puffins at one another and smear yogurt on the table. Amped-up from my run, I start slinging sandwiches at the six-year-old. He's insatiable, sometimes consuming three PB&Js before 9 a.m. (Along with the sponges and the detergent, I arrived with three large jars of peanut butter.)

Virtual schooling is an elaborate dance of screen-sharing and multiple logins and passwords, but it gives everyone a daily benchmark: We will be dressed and ready when the morning meeting begins. My economist husband goes out to our car, parked in the driveway, to deliver reports to his clients and soundbites to Bloomberg TV. My historian father brings his laptop and his books (Samuel Pepys, Michel de Montaigne, Thucydides) to the garage. Our 27-year-old au pair, who—let us establish this up front—is the hero in this story, takes the kids to the basement to start their Zoom-oriented morning. I live in fear of the day when this steely but warm Moroccan-Italian woman, whose managerial skills would be suited to running a midsize corporation, is scheduled to depart, and the full reality of homeschooling three kids under seven will hit us. She was meant to leave mid-April, but the State Department granted an extension to au pairs already in the country—it's an odd feeling when a vast and faceless bureaucracy assuages your greatest fears, but I do not question the blessing. It allows us to dip back into a state of glorious denial about her imminent departure and keeps our behavior in check. We consider her family at this point—especially at this point—but we cannot be our worst selves in front of her.

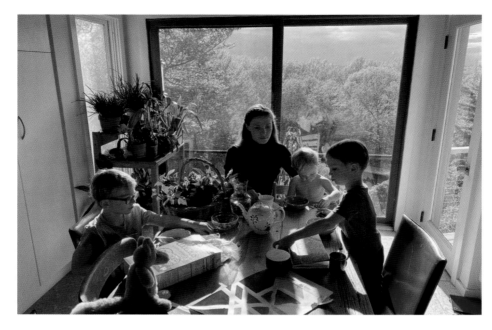

Schama with her children.

Lunch is a choreographed affair; the kids eat early, then my husband and I sneak down to scarf a sandwich standing up, and then my parents prepare their meal in a far more genteel manner, conversing with a civility that makes me question my own marriage's barbarian M.O. It takes a lot to keep the commissary, as my dad has taken to calling it, going. We run the dishwasher two times a day. We have only brought a small suitcase of clothing each, and despite my mother's concerns that we are straining the septic tank (we are), we wash and dry in a seemingly endless cycle.

In the afternoons, when the simulacrum of school is over, the kids often spend hours outside. My mother, a just-retired geneticist, has given them a plot within her vegetable garden to dig, and she has intuited the golden formula of child activities: tiring, simple, time-consuming. The kids return to the house with twigs in their hair and their faces streaked like halflings. My husband laughs and points to this as evidence for why I shouldn't worry about the summer—an ongoing and pointless discussion we like to have as to what we will do. There are cliffs nearby, I point out to him, and bushes full of Jurassic thorns and broken beer bottles and rusting lawn furniture in the woods—remnants from some teenage tailgate when all the kids wore bell-bottoms. It'll be fine, he says. The older one will watch the baby.

And in some ways, he is right: What is a hazard in this new world? When we were in the city, every surface was an enemy. At our last visit to a playground, a kid was coughing, circling my children like an incubus. Poor boy, he just wanted to share their ball. *Go play over there,* I hissed at my oldest, jerking my head toward an abandoned corner of the lot.

On a work call in my bedroom, I see the three boys wandering down the hill and into the woods, their rubber boots a bright flash of yellow against the brown and barely thawed earth. It seems okay. I stay on the call.

One weekend we go for a careful hike in a state park, masks around our necks, pulled up whenever we have to pass someone on the trail. I'm in the front of our brigade, and I see something slither across the path in front of me, about the thickness of a rope, a muddy color, vibrating its tail with a telltale rattle. I turn and hold my hands up to the children, telling them to stop, rasping at them to be quiet. But I cannot scare these kids, I realize in an instant. I cannot add another thing to the troubles that they are no doubt absorbing. I ask my mother, who grew up on a ranch in the middle of rural Nevada, if there are rattlesnakes in the East, and she says, cooly, *Sure.*

Six weeks into multigenerational living, we have broken: a closet door, the top of a tagine, a porcelain roasting dish, a wine glass, a large pasta bowl, two screen doors, a toilet, a different toilet's seat, the top of a shower spray nozzle, and a mostly full bottle of perfume that made the downstairs bathroom reek of roses for a week. My husband finds the same pasta dish on eBay—my

father thought it was from Italy, but it turns out it was a late-'90s Williams Sonoma vintage. It arrives in shards.

A playwright we all admire dies. We tear up at George W. Bush's stronger-together video. *Dubya!* Warmonger! Don't we, good liberals, hate him? A poet who I once edited dies, and I have to go upstairs while everyone is cleaning up the dishes and cry a little. My husband and my mother debate the p-value for remdesivir, while I shush the kids to try to hear them.

The baby recalls the yucks he got at Passover when he let out a well-timed "freedom!" at the escape-from-bondage part in the seder story, and he reprises the bit daily—a cry that takes on an increasingly eerie resonance as we come to terms with the realization that we are not going anywhere anytime soon. Usually, when we call my husband's parents in Kentucky, we're able to end the call with some sense of when we might see them, even if it's six or nine months in the future. When we FaceTime with them now, it goes unspoken that we can make no such promise. Despite the busy suburban kibbutz we have created, it's impossible to escape not just the horrors of the virus, but the low-grade anxiety that we have no idea what's ahead of us.

There is only so much of this we can hold in our heads, however, especially when there are eight mouths to feed. When I deliver heaping dishes—a vat of curry, four whole heads of roasted broccoli, a small mountain of rice, a boat of peanut sauce—to the table, I cannot believe that we will eat it all. Then 40 minutes later, I am packing just two small Tupperware containers with the leftovers and wondering what I'll cook when we do it all again. We order three gallons of milk and a pint of half-and-half each week and drink it all.

The baby has taken to falling asleep at the table while he's eating, sometimes mid-bite, like an elderly relative who doesn't want to miss out on the festivities. *He's so like my father,* my own father says when this sleep-eating happens, and I remind him that we named the baby after this grandfather I never had the chance to meet but always liked the sound of. My father has a nice relationship with my children, but it's the kind of relationship one has with grandkids one sees every other month or so. Over the past few weeks, however, he's become more intimate with all of them—sometimes scolding, but also sharing private conversations and inside jokes. *Hello big belly,* my oldest greets him one morning. *Hello four-eyes,* his grandfather snaps back.

One evening after dinner, I ask my parents if it's okay that we're still living with them, if it's okay that we stay longer. I know we are a strain, in all the obvious ways—loud voices, broken dishes, a bursting fridge that struggles to keep cool with all the curious hands constantly opening it—but there are the more diffuse pressures as well: We fill the house with our moods, light and dark, the clouds that six people carry. *Of course,* they answer. *If you left we don't know when we'd see you again.* There's a cold logic to this. When we return, even carefully, to some version of life as we knew it in the city—going into bodegas and drugstores and gathering for socially distanced cocktails on friends' stoops—we may pose too much of a risk for them to welcome us back. My mother—the scientist—understands sterile technique, and everyone, she tells us, is terrible at it.

I suspect that each person in this house will remember this time differently. For my parents, I hope they will see it as a precious stretch, when they got to watch their youngest grandchild obtain the power of speech, a new word every day. But I also recognize that they may feel cheated that life as they knew it was taken from them. For my husband and me, there is the stress and juggle, but we are also fortunate to be able to acknowledge an opportunity to contemplate what matters and what we want to do with our days now that distractions—good and bad—are gone. For our au pair, this is an odd decrescendo following a year of electric city living, days spent escorting the children on the subway, nights at Chinatown clubs. Before the pandemic shut everything down, my husband and I had urged acquaintances to hire her or at least meet her for a coffee. I feel an itch to follow up on those emails, but what would I possibly say? The older two children know about "the virus," as they call it—always with the definite article—but it's my hope that they will recall this as a wilder, freer episode in their normally regimented young lives. *I miss my friends,* the oldest sometimes says, out of nowhere, but he has his brothers, his babysitter, his grandparents.

In the living room, there is a low-slung, '70s-style swinging couch in front of the fireplace. When I told a childhood friend I was quarantined at my parents' house, it was the first thing she asked about: Do they still have it? When I was in elementary school and we moved into the house, my younger brother and I camped out on this suspended sofa. It was a little lifeboat from which we could observe the movers as they traipsed back and forth in their heavy boots, reassembling the contents of our previous home within this new and foreign one. What life had we left? What new life awaited in this unfamiliar place? My own kids are now often stationed on this couch, rocking back and forth, making it their own vessel to carry them through.

JOSH OLINS, NEW YORK

"To be represented as a blur could be reflective of the passing of time," said the photographer, appearing with his partner, Constanza. "Gardening has been extremely satisfying and a way of being directly in contact with nature: To observe something that progresses so slowly—the simplicity of a fern pushing through the soil and unfurling over a week—has definitely installed a new sense of calm in me."

BELLA AND GIGI HADID, PENNSYLVANIA

The models took their picture on the family farm. "We are sending love and strength to everyone," Gigi said, "especially those who are suffering and the people on the front lines; the doctors risking their lives every day, and the paramedics and cops and people who work in grocery stores. It's lucky that a lot of us can work from home. But there are a lot of people who can't."

IMAAN HAMMAM, NEW YORK

"My spirits have been up and down—some days are better than others," the model acknowledged. "I just try to stay positive and take the time to self-reflect. Most days, I wake up and shower and get fully ready. By that, I mean I do my hair and makeup and put on a cute outfit. I feel like I get so much more out of the day."

CAROLYN MURPHY, LOS ANGELES

"I actually came out here for a job," the model said. "But as things were starting to kind of get wonky at the beginning of March, I decided to stay. These days, you're riding these waves of thoughts and emotions and fears and anxieties, but instead of trying to tune them out, it's time to go anywhere the sun hits and tune in."

JOAN SMALLS, PUERTO RICO

"I'm at my parents' house, where I grew up on six acres in the countryside," the model said. "It's the true essence of my core, and no matter how crazy and overwhelming the rest of the world may be, home always brings me to a serene and peaceful state of mind where I feel loved and protected."

CHU WONG, SHANGHAI

"We have all gone through a lot with the coronavirus," the model said. "It's important that we take care of ourselves and others by staying home. We will get through this."

JAWARA, NEW YORK

"My sister works in the medical field and she's doing all these crazy hours, so I just decided to temporarily adopt her kids," the hairstylist said. "And then while I was doing that, my other sister was like, 'Well, what about me? I have to work too!' So now I'm watching six to seven kids a day (including Khamarie, near right, and Oninye-Che, far right). But they have the most optimistic outlook on the situation. They're kind of like my little heroes."

LILY ALDRIDGE, NASHVILLE

"I'm in my children's playroom, reading one of our favorite stories," said the model. "This is something that we do a lot when we are home together, whether it's me reading a book to my kids or my daughter reading a story on her own, which she loves to do now. My son is always bringing books to me and sitting on my lap!"

TESS MCMILLAN, UPSTATE NEW YORK

"Painting and drawing is keeping me calm and collected right now," the model said. "On an average day I have a mind that is running a mile a minute, and that is especially true right now. But when I sit down and start working on a piece, my mind hyper-focuses, and everything resets for me. About a week ago, I auctioned off my first painting in order to donate the proceeds to a few organizations providing aid during this crisis. It made me so happy to do so because I was able to take my art—something I love—and use it for good."

UGBAD ABDI, NEW YORK

"My friend Miski and I have been talking to each other every day during quarantine," the Somali-born model said. "In this time of isolation from the world, sunlight and checking in with loved ones has helped me feel productive and sane."

JULIEN D'YS, NEW YORK

"In some pictures, you can see my *carnet* because I write a lot, and I always draw and paint when I'm not working," said the hairstylist, who typically lives between New York and Paris. "I've also been planting seeds, and I love seeing the plants growing every day. We're very lucky because we're close to Central Park, and we can hear the birds. Every day I'm watching the trees growing up and the leaves coming in. I try to forget and try to relax."

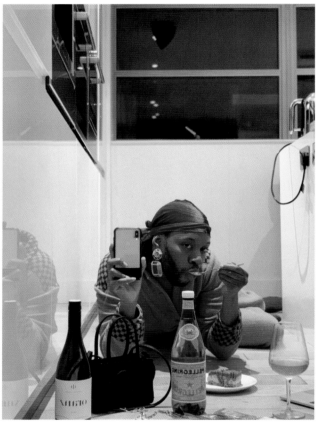

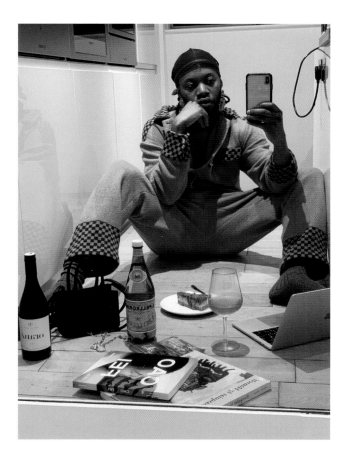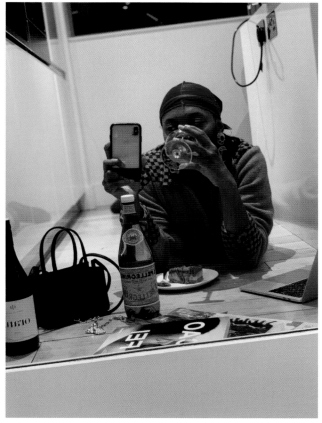

JEREMY O. HARRIS, LONDON

"I took these pictures in my kitchen, where I do a lot of my work," said the playwright and actor, who had traveled to England with his play *Daddy*. "I'm an extroverted person— I'm very social, and usually so ready to go out—but what's been nice is discovering that I'm an indoor cat."

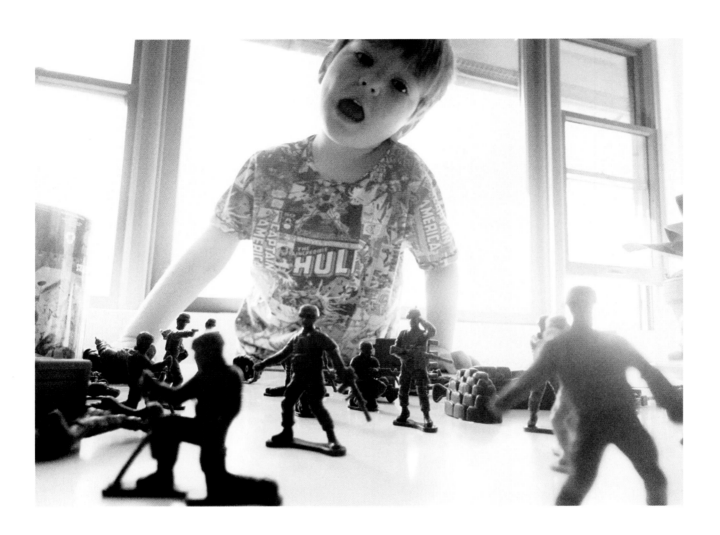

**DANIEL JACKSON,
UPSTATE NEW YORK**

"These pictures are of my youngest, Noah, confined indoors, directing the invasion of the kitchen table and interrupting his brother and sister's online school," the photographer said.

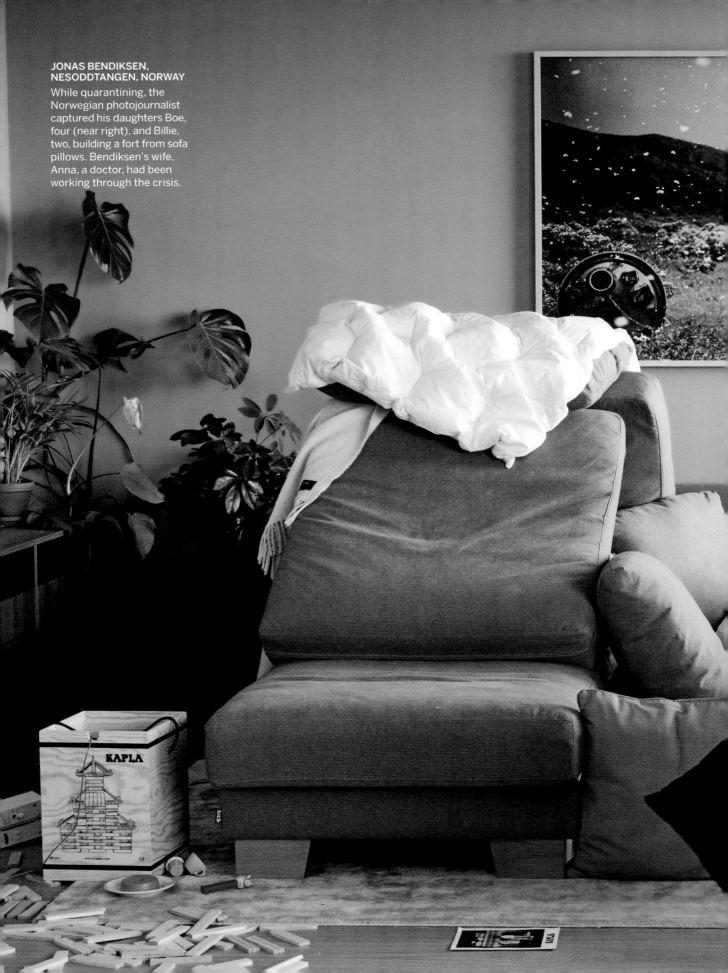

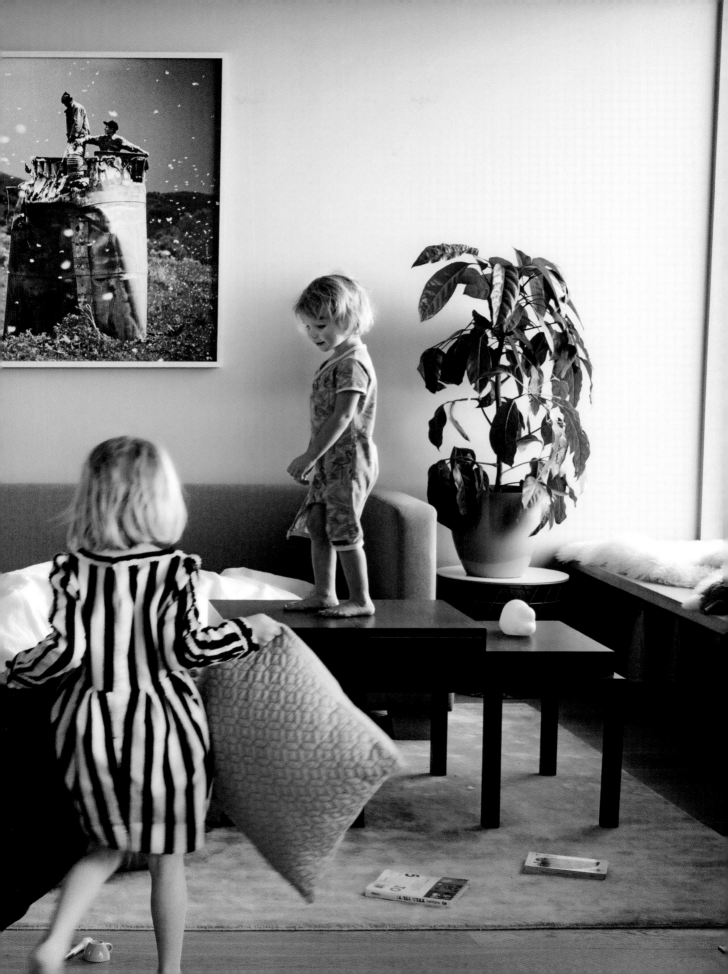

ETHAN JAMES GREEN, NEW YORK

"I started living alone for the first time in a new apartment a week before the quarantine started," the photographer said. "The space is unfurnished, so I've turned it into a testing ground for photography, shooting natural-light still lifes and self-portraits. It's bare-bones, and it has been nice to revisit my beginnings as a photographer."

ELIZABETH PEYTON, *SUNNY (ISOLDE),* 2020

From New York, the artist gave *Vogue* a pastel self-portrait with her dog, Isolde. "It's very much in her spirit—she reminds me how magical nature is," Peyton said. "As the drawing was coming along, I was thinking, Where are these colors coming from? Ah, it's from the sunrises I've been looking at."

YOSHIYUKI OKUYAMA, TOKYO

What is now his studio was once the home of the photographer's grandmother, an avid gardener. Shooting flowers there, Okuyama described the powerful connection he felt to her memory: "It is like a conversation with her," he said.

TONNE GOODMAN, NEW YORK

"These tulips are my favorite," *Vogue*'s sustainability editor said. "They open wide and have black centers. I buy them at the deli. Flowers bring joy, and joy brings optimism."

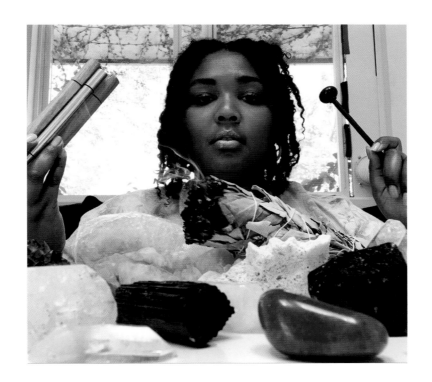

LIZZO, LOS ANGELES

"I have my crystals that I charge, and I have my single-note bell, and I have a flute; it's called a Toot," said the singer. "I light sage, or I light Palo Santo or a candle or anything that can bring some sort of texture into the air. Then I just like to sit and connect with people. I know a lot of people use meditation as a form of calming down and centering themselves, but recently I've been using meditation as a form of connectivity, to where it's like I can mindfully and metaphysically connect with all of the people in the world. You know what I mean? I've been using meditation as a form of bringing myself closer to everybody and to the heart of the world, and it's really worked. It's really worked for me."

ACKNOWLEDGMENTS

Postcards From Home was a collaborative effort from beginning to end, involving a broad community of editors. Thank you to Taylor Antrim, Jessie Heyman, and Chloe Schama for editing the essays and helping to shape the book's point of view; to Raúl Martinez and Parker Hubbard for the book's elegant layout. Jenna Adrian-Diaz, Christian Allaire, Keaton Bell, Hamish Bowles, Mark Holgate, Dodie Kazanjian, Janelle Okwodu, Marley Marius, Chioma Nnadi, Lilah Ramzi, Emma Specter, and Sarah Spellings all contributed to the interview efforts. Marley and Eliseé Browchuk were tireless and heroic in securing permissions and contracts, as was Toni Boyd. Thank you to Nic Burdekin, Danielle Gruberger, Robyn Lange, Lindsey Law, and Fabbiola Romain for facilitating so many of the excellent images depicted here. David Byars, Jason Roe, John Mok, and Hollis Yungbliut all helped make production run smoothly—and quickly! Thank you also to David Agrell, Robin Aigner, John Banta, Mira Ilie, and Christiane Mack. Our thanks to Anthony Petrillose at Rizzoli for his support and enthusiasm for this project. Anna Wintour, who initiated much of the work that this book captures, has our deep appreciation as well.

CREDITS

Book design by Parker Hubbard

Photograph by Irving Penn: *Rose, 'Colour Wonder,'* London, 1970 © The Irving Penn Foundation: **9.** © David Hurn/Magnum Photos: **16–17.** Whitney Cox/ The Shubert Archive: **19.** © Richard Mosse. Courtesy of the Jack Shainman Gallery: **23.** Jean-Pierre Cassigneu. *Sieste,* 1969. Oil on canvas, 25 ⅝" x 31 ⅞". © 2020 Artists Rights Society (ARS), New York: **54.** © Peter Van Agtmael/ Magnum Photos: **60–61.** © Martin Parr/Magnum Photos: **93.** © Chien-Chi Chang/Magnum Photos: **116–117.** © James Turrell. Courtesy of the Pace Gallery: front cover, **130–131.** © Jawara Wauchope/Art Partner: **151.** © Enri Canaj/Magnum Photos: **144–145.** Photographed by Ilker Akyol: **158–159.** © Jonas Bendiksen/Magnum Photos: **164–165.**

First published in the United States of America in 2020 by
Rizzoli International Publications, Inc.
300 Park Avenue South
New York, NY 10010
www.rizzoliusa.com

Copyright © 2020 Condé Nast
Foreword: Anna Wintour

Publisher: Charles Miers
Associate Publisher: Anthony Petrillose
Project Editor: Gisela Aguilar
Production Manager: Maria Pia Gramaglia
Design Coordinator: Olivia Russin

Printed in USA

2020 2021 2022 2023 / 10 9 8 7 6 5 4 3 2 1

ISBN: 978-0-8478-7023-3
Library of Congress Control Number: 2020910451

Visit us online:
Facebook.com/RizzoliNewYork
Twitter: @Rizzoli_Books
Instagram.com/RizzoliBooks
Pinterest.com/RizzoliBooks
Youtube.com/user/RizzoliNY
Issuu.com/Rizzoli

COVER: Kendall Jenner, Los Angeles